IMAGES
of America

SWEDES OF THE DELAWARE VALLEY

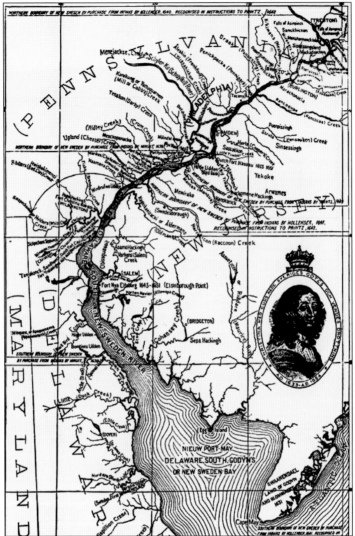

This early map of New Sweden (*Nya Sverige*) shows the areas of Pennsylvania, Delaware, New Jersey, and Maryland, along the Delaware River, settled by early Swedes and Finns. The first expedition to North America embarked from Gothenburg in 1937 and was organized by Clas Fleming, a Swedish admiral from Finland. Their settlement in the New World, Fort Christina, was named after Queen Christina of Sweden. The site now encompasses the city of Wilmington, Delaware. The original settlement expanded to Fort Nya Elfsborg (Salem, New Jersey) and Fort Nya Gothenborg (on Tinicum Island). This image was first published in the 1876–1899 *Nordisk Familjebok*. (Courtesy of ancestry.com.)

ON THE COVER: On June 27, 1938, Prince Bertil, Duke of Halland, came from Sweden to celebrate the 300th anniversary of the arrival of the Swedes in the Delaware Valley. Prince Bertil gave his first speech, representing the Swedish royals at public functions in the Delaware Valley. For additional information please see page 112. (Courtesy of the American Swedish Historical Museum.)

IMAGES
of America

SWEDES OF THE
DELAWARE VALLEY

Margaret Murray Thorell, Ph.D.
Foreword by Tracey Rae Beck

ARCADIA
PUBLISHING

Published by Arcadia Publishing
Charleston, South Carolina

Printed in the United States of America

Library of Congress Control Number: 2010930234

For all general information, please contact Arcadia Publishing:
Telephone 843-853-2070
Fax 843-853-0044
E-mail sales@arcadiapublishing.com
For customer service and orders:
Toll-Free 1-888-313-2665

Visit us on the Internet at www.arcadiapublishing.com

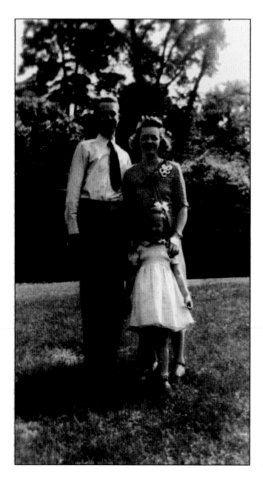

This book is dedicated to my Swedish father, Algot, and my mother, Peg, who believed in those Swedish values of education, social democracy, entrepreneurialism, and family. (Author's collection.)

CONTENTS

FOREWORD

I was thrilled when Marge Thorell agreed to work with Arcadia Publishing to produce a volume about Swedes in the Delaware Valley. It is easy to miss the influence of the Swedes in this area until someone points out just how important they have been, and then suddenly the evidence becomes clear all around. This book shows, in pictures, the long-standing contributions, traditions, and celebrations of this community.

The American Swedish Historical Museum was born in a spirit of celebration. Swedes from all over the country joined together and envisioned a grand museum where the achievements of their fellow Swedes could be saved and commemorated for all to see. And what better place to establish it than the birthplace of our nation AND the original location of the Swedish settlement in America—Philadelphia? The museum's cornerstone was laid by Swedish royalty in 1926 at the site of the sesquicentennial celebration of the Declaration of Independence. It was also the site of a 1653 land grant from Queen Christina to Sven Skute, a military officer in the New Sweden Colony. At the time of Sven Skute, there were only 600 or so Swedes in the Delaware Valley. By the time of the founding of the museum, over one million Swedes had come to America in just a few decades and had made an unmistakable mark on the whole country.

The museum's founder envisioned each gallery as devoted to a certain area of achievement where the work of notable Swedish Americans would be shown. These areas included science, engineering, art, music, philosophy and religion, building, and architecture, among others.

In the 21st century, we are much more interested in the history of the common person than the museum's founders were 100 years ago. We want to know what life was like for the Swedish immigrants who made America their home. How did they survive in a country whose language was foreign to them? What were conditions like for the ones working as domestic servants, miners, and builders? Here is where a book like this one makes a contribution. It is not one family's history, nor is it only a story of great achievers. It is a compilation of pictures that show the people who built what we know of as Swedish America today. The Delaware Valley, more than any other area of this country, has the longest history of Swedish settlement. These are the people you will meet in these pages.

—Tracey Rae Beck
Executive Director, American Swedish Historical Museum

ACKNOWLEDGEMENTS

The American Swedish Historical Museum has, from its beginning, been a repository for Swedish culture in the Delaware Valley and the United States. It is the oldest museum in the country dedicated to things Swedish. The museum's library, archives, photograph collection, and databases have contributed significantly to this book. I wish to thank the staff and other members of the museum, without whom this book would not have been possible. I especially wish to thank both Tracey Rae Beck, executive director, and Carrie Hogan, curator, for their help and support.

However, others contributed as well. I am particularly grateful to Grace Conran, president, board of directors, Friends of the Swedish Cabin, Delaware County. Grace was the first to open up her treasure trove of artifacts for my inspection, read portions of the book, and provide feedback. I also want to thank Thomas R. Smith for his help and historical information. Many others deserve recognition: Theresa R. Stuhlman (preservation and development administrator), Fairmount Park Historic Resources Archive; Kalmar Nyckel Foundation; Karen Lightner (curator and art department head); Aurora Deshauteurs (Print and Picture Collection curator) and Ted Cavanagh (Print and Picture Collection), Free Library of Philadelphia; Joel Frye (curator), Bartram's Garden; Jim Yurasek (press contact and information lead), Delaware Division of Historical and Cultural Affairs; Rebecca L. Wilson, Old Swedes Foundation; Josh Brown, The Historic Elk Landing Foundation, Inc.; Greta Greenberger (director), City Hall Tours; Lee Arnold and Elsa Varela, Pennsylvania Historical Society; Deb Boyer (project manager), Azavea and *Philly*History.org; Brenda Galloway-Wright (associate archivist) and Ann Mosher (bibliographic assistant), Urban Archives, Samuel L. Paley Library, Temple University; Ellen Rendle (curator of images), Delaware Historical Society; Kristina O'Doherty; and Goren Buckhorn.

I would be remiss if I did not acknowledge Elizabeth Farmer Jarvis, author of *Chestnut Hill* and *Chestnut Hill Revisited*, who offered excellent advice when I needed it most. I especially want to thank my proofreader, Jay Makary. In addition, I received great help from my publisher at Arcadia Publishing, Erin L. Vosgien, who provided support and information at crucial moments.

I especially wish to thank Rev. Dr. Kim-Erik Williams, Margaret Sooy Bridwell, and Ronald A. Hendrickson, Esq., from the Swedish Colonial Society, and especially the Nordiska Museet in Stockholm, Sweden.

Finally, my husband, Klaus Krippendorff, Ph.D, deserves many thanks for not only lending his support throughout this project, but also for taking many of the photographs that appear within.

INTRODUCTION

In the middle of the 17th century, Sweden was for a short time the undisputed ruling power of Europe during the reign of Queen Christina. Its territories included Finland, Estonia, and parts of Russia, Poland, Germany, and Latvia. In 1632, Christina ascended the throne as queen regnant at the young age of 6, upon the death of her father, King Gustavus Adolphus. She reigned successfully until 1654, during the time of Sweden's greatest influence. Desirous of expanding its power, Sweden wanted to conquer the New World.

In late 1637, a Dutch-built armed merchant ship, the *Kalmar Nyckel*, sailed out of Gothenburg, Sweden, to America. It arrived carrying 24 settlers of Swedish, Finnish, German, and Dutch descent. They set down on March 29, 1638, along the Delaware River in what is now Wilmington and established the first permanent European settlement in the Delaware Valley, which they named Fort Christina, after their queen. The *Kalmar Nyckel* would eventually make four additional voyages to the New World, bringing more than 600 Scandinavian settlers who moved from that initial site into other areas of the Delaware Valley.

Nya Sverige (New Sweden) eventually encompassed parts of Pennsylvania, Delaware, Maryland, and New Jersey along the Delaware River. The original settlement expanded to New Jersey, as well as other places as far south as Elkton, Maryland. These areas were under Swedish rule until 1655, when the Dutch, led by Gov. Peter Stuyvesant, moved an army up the Delaware River, causing the surrender of many of the forts in the settlement. However, before the Dutch conquered the settlers, the Swedish colony appointed John Björnsson Printz first royal governor of New Sweden. He arrived in the colony on February 15, 1643, and led the colony from that time until 1653, fostering its expansion.

While Sweden's reign in the New World was short, her influence was strong and long lasting. America, considered a bastion of liberty and freedom—a legacy in part from the Swedes—became a country known for its hard work and liberal views, eventually embracing the notion of the welfare state, a government that took care of its people.

In the early 19th century, the United States once again became a beacon for a new generation of Swedes, who came to America during Sweden's great period of emigration. Because of industrialization, famine, and general political unrest in Sweden, from 1870 through 1910 over one million Swedes arrived in this country.

Much of the influence of these Swedes can be found in the Delaware Valley today, which is seen in area churches and log cabins. These early churches, such as Old Swedes Church in Wilmington and Gloria Dei Church in South Philadelphia are examples of Swedish design. Swedish log cabins along the banks of Darby Creek, in Delaware County are another manifestation of Swedish ingenuity and are believed to have been built by early Swedish settlers between 1638 and 1655. Occupied for three centuries, many of these cabins fell into disrepair and neglect in the mid-1900s.

Many Swedish personalities have contributed to the culture of the Delaware Valley. These included Jenny Lind, the "Swedish Nightingale" who sang at Musical Fund Hall, Amandus Johnson,

scholar and first curator of the American Swedish Historical Museum, and John Morton, Swedish American signer of the Declaration of Independence.

Famous Swedish industries and corporations have also stabilized the economy of the Delaware Valley as well as contributed to the quality of life of the citizens. Corporations like home furnishings retailer IKEA, clothing store H&M, pharmaceutical giant AstraZeneca, timber company SCA, and others all have left their imprint on the area.

Music and the arts have had a significant influence on the culture of the United States. The films of Ingmar Bergman are still popular in this country, and the music of ABBA is well known. But before there was ABBA, there was Jenny Lind, who came to Philadelphia and gave one of her sterling performances. However, the most compelling influence of modern times can be seen largely in Sweden's design ethos. Modern Swedish design, as conceived by IKEA through the design sensibility of Carl and Karin Larsson, is immensely popular in the United States today. IKEA has several major stores in the Delaware Valley and many school dormitories, newlywed houses, and bachelor pads are decorated by IKEA. For the more affluent, the Larsson creations are seen in many design books and publications and in the influence of interior decorators who espouse the clean lines and airy feeling of Swedish décor.

Swedish contributions to the Delaware Valley began in the 1600s and continued to this day. From famous personalities and organizations to street names and neighborhoods, Swedes and Swedish Americans have influenced the Delaware Valley. This special culture has been immortalized by the American Swedish Historical Museum.

One

AMERICAN SWEDISH HISTORICAL MUSEUM

The American Swedish Historical Museum in South Philadelphia is the oldest Swedish museum in the United States. The museum was founded in 1926, when its cornerstone was laid by Sweden's crown prince and future king Gustaf VI Adolf. At that time, noted scholar Amandus Johnson was elected president.

On June 28, 1938, the formal dedication of the museum building took place. The event was coordinated with the 300th anniversary of the Swedish arrival at Fort Christina. Sweden's Prince Bertil and Crown Princess Louise made up the royal party that dedicated the museum.

The building's design was based on a 17th-century manor house in Södermanland, Sweden, and was designed by architect John Nydén, a Chicago-based Swedish American. The exterior is also modeled on Mount Vernon.

The museum has been dedicated to preserving and promoting Swedish and Swedish American cultural heritage and traditions for nearly 80 years. It is a place where Swedes, Swedish Americans, and people of all nationalities who appreciate Swedish contributions to history, art, architecture, music, science, and technology can come together.

The museum is located in Franklin Delano Roosevelt (FDR) Park in South Philadelphia on land that was granted originally to the 17th-century settlers by Queen Christina. The museum today consists of 12 permanent galleries, one changing exhibition gallery, and a library. Many activities and celebrations have taken place on the grounds and in the museum over the years.

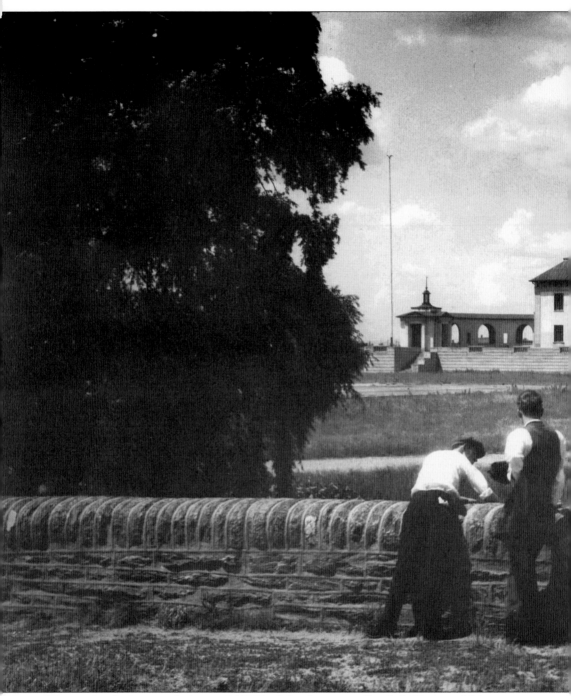

This undated photograph (around 1930) of the American Swedish Historical Museum was reputedly taken by the noted historian and scholar Amandus Johnson, founder of the museum, which is the oldest Swedish museum in the country. The image shows the grounds of a virtually uninhabited FDR Park. Originally called League Island Park, FDR Park was created in 1914 by the Olmstead brothers. Some 300 acres of marsh were filled and regraded. This process was considered one of the more remarkable works of land reclamation of its day. In 1926, the park hosted the

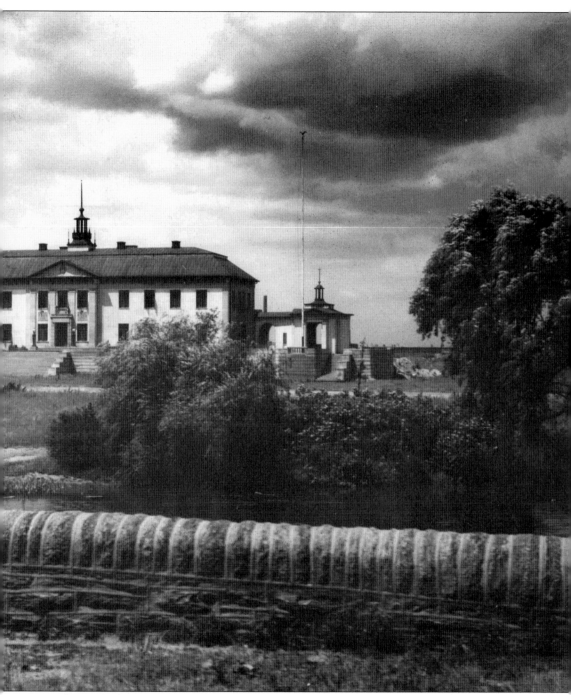

national Sesqui-Centennial International Exposition, a celebration of the nation's 150th birthday. On June 2, 1926, Sweden's crown prince and future king Gustaf VI Adolf placed the museum's cornerstone. The formal public dedication of the museum took place 12 years later. This event was set to coordinate with the 300th anniversary of the Swedish arrival on the Delaware shores. The park's boathouse, gazebo, and the museum are lasting reminders of the exposition. (Courtesy of the American Swedish Historical Museum.)

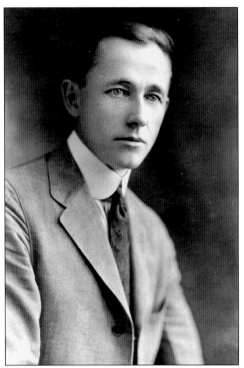

This portrait of Amandus Johnson (1877–1974) was taken in the 1930s, when he was studying for his doctorate at the University of Pennsylvania. He was born in Långasjö, Sweden, a small village located in Kalmar County in the province of Småland. He was three years old when his family settled in Minnesota. He attended Gustavus Adolphus College in Minnesota and eventually came to Philadelphia to pursue his graduate studies. Dr. Johnson was a very influential member of the Swedish American community in the Delaware Valley. (Courtesy of the American Swedish Historical Museum.)

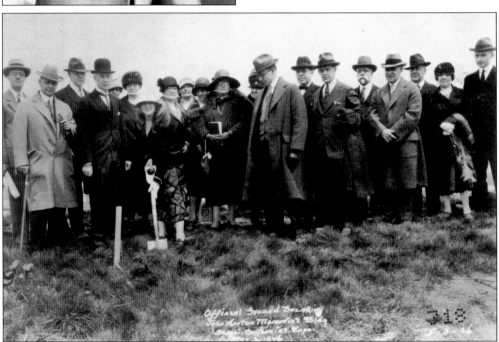

In this photograph dated April 4, 1926, dignitaries from Pennsylvania and the American Swedish Historical Museum participated in the official ground-breaking ceremony of the museum, which was initially called the John Hanson–John Morton Memorial Building. This name was eventually changed. Celebrations were led by the wife of W. Freeland Kendrick, who served as mayor of Philadelphia from 1924 to 1928. (Courtesy of the American Swedish Historical Museum.)

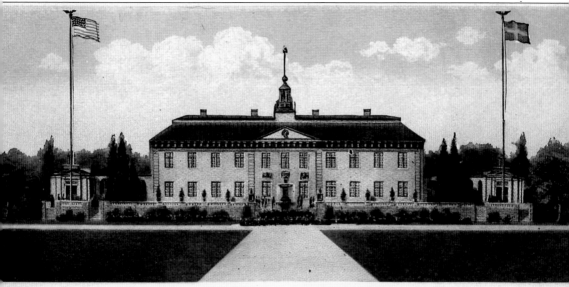

John Hanson -- John Morton Memorial Building
Sesqui-Centennial International Exposition
Philadelphia, Pa.
Devoted to the preservation of achievements in America by
citizens of Swedish descent

★

109714

This is a reproduction of the front side of a postcard of the American Swedish Historical Museum created by John D. Cardinell, official publisher for the Sesqui-Centennial International Exposition. The 1923 postcard uses the museum's former name. According to the postcard, the museum was "devoted to the preservation of achievements in America by citizens of Swedish descent." The card shows both the American and Swedish flags. The back of the postcard reads, "Greetings from Philadelphia the Cradle of Liberty in Celebration of the 150 Years of American Independence, June 1 to December 1926." There is an image of the liberty bell with the dates 1776 and 1826. It was on June 2, 1926, that the cornerstone for the museum was laid by Swedish royalty at the site of the sesquicentennial celebration of the Declaration of Independence. It was also the site of a 1653 land grant from Queen Christina. (Courtesy of the American Swedish Historical Museum.)

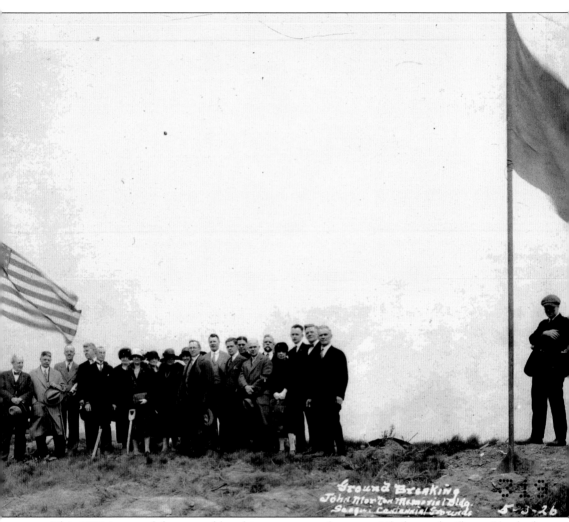

This 1926 image of the ground-breaking ceremony (see page 14) shows the flags of both the United States and Sweden. The museum's aim at the time was to preserve the memory of the New Sweden colony, which dated from 1638. It would be some time, however, before the museum would actually be erected. The building's design was based on Eriksberg, a 17th-century manor house in Sweden. Now the museum has 12 galleries devoted to the history of New Sweden as well as other exhibits that detail Swedish history and culture. One of the galleries recreates a Swedish *stuga* (little house). There is an exhibit showcasing Alfred Nobel and various Nobel prizes and Nobel recipients. The museum also houses paintings by some of the most famous Swedish or Swedish American painters, such as Anders Zorn, Carl Larsson, and Christian von Schneidau. (Courtesy of the American Swedish Historical Museum.)

Shown here is the official invitation to the laying of the cornerstone, which was in conjunction with the Sesqui-Centennial International Exposition. Music was provided by the 12th United States Infantry Band, with an invocation by Rev. Dr. George W. Sandt. Many officials spoke, including Philadelphia mayor W. Freeland Kendrick and U.S. Secretary of Labor James J. Davis. The cornerstone itself was laid by Crown Prince Gustaf Adolf. (Courtesy of the American Swedish Historical Museum.)

Programme at the Corner-stone Laying of
The John Morton Memorial Building
June 2, 1926

Music—The 12th United States Infantry Band

Invocation—Rev. Dr. George W. Sandt

Introducing the Chairman—Dr. Amandus Johnson, President of The American
Sons and Daughters of Sweden

Chairman—Judge Harry Olson, of Chicago

On behalf of the Society of Signers—John Calvert, Vice-President
General of the Society of Signers

Dedicatory Address—Dr. H. McI. Morton, of Minneapolis

Address—Hon. W. Freeland Kendrick, Mayor of Philadelphia

Address—Dr. Clyde King, Secretary of the
Commonwealth of Pennsylvania

Address—Hon. James J. Davis, Secretary of Labor

Laying of Corner-stone by His Royal Highness,
Crown Prince Gustaf Adolf of Sweden

Song—The Scandinavian Glee Club

Music—The 12th United States Infantry Band

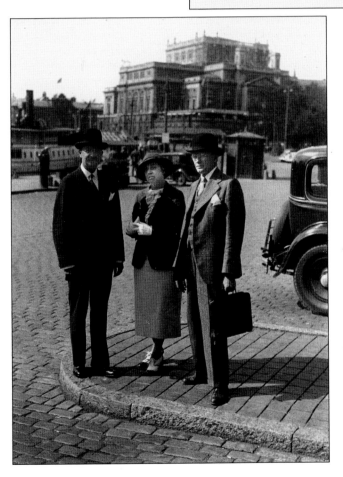

Taken in 1935, this photograph shows members of the American Swedish Historical Museum on an official visit to Stockholm, Sweden. From left to right are Ormond Rambo Jr., Edna Marie Rambo, and Dr. Amandus Johnson. The officiating members of the museum spent a great deal of time in Sweden fund-raising and maintaining relationships with Sweden. (Courtesy of the American Swedish Historical Museum.)

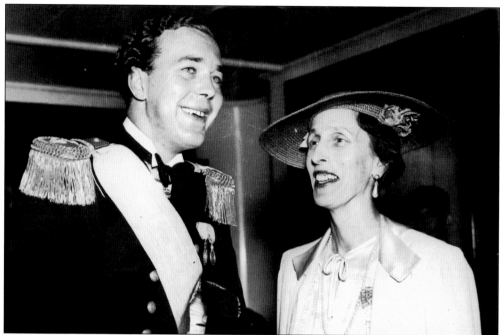

During the Swedish royals' visit to Philadelphia in 1938, Prince Bertil accompanied Crown Princess Louise to various events in the Philadelphia area while her husband, Crown Prince Gustaf Adolf, was ill aboard his ship, the MS *Kungsholm*. The crown prince was stricken while crossing the Atlantic, and three attacks of a kidney ailment prevented him from taking part in the ceremonies. According to the June 28, 1938, edition of the *Evening Bulletin, Providence*, the prince said, "This is the worst luck I have ever had." (Courtesy of the American Swedish Historical Museum.)

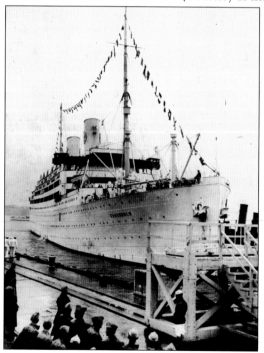

On March 17, 1928, the new MS *Kungsholm* was launched by Blohm and Voss for the Swedish American line. The ship's interiors were designed with off-season cruising in mind, with her passenger capacity shrunk from 1,344 on liner service to around 600 for cruising. She was also one of the first liners with interior decorations in the art deco style. She eventually would became the official ship of the Swedish royals. The Swedish American line was the main connector between Sweden and North America in the days before airlines. (Courtesy of the American Swedish Historical Museum.)

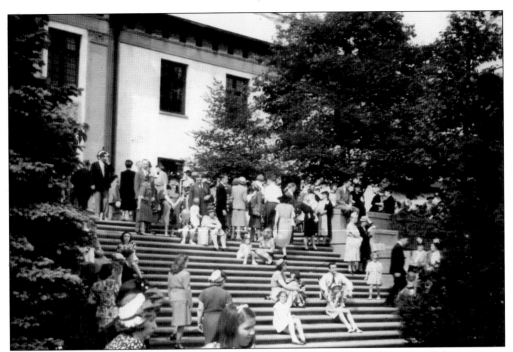

The annual spring fete, pictured here on May 24, 1947, was held on the steps of the museum. The fete was attended by many in the Delaware Valley, and it brought young people to South Philadelphia. People of all ages enjoyed both the grounds of the museum and the many exhibition rooms. (Courtesy of the American Swedish Historical Museum.)

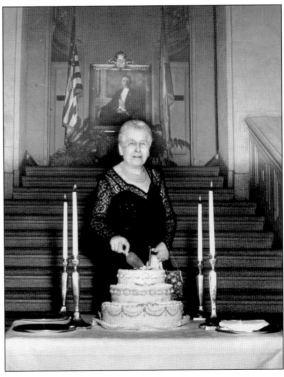

Many events take place at the museum throughout the year. Here on June 30, 1948, Mrs. Martin Borch cuts a cake for the Jubileum Bal (Jubilee Ball) at the museum, which was held to celebrate the Swedish Pioneer Centennial. This event encouraged a growing interest in American Swedish history, with many people beginning to trace their Swedish roots. (Courtesy of the American Swedish Historical Museum.)

On June 29, 1948, members of the museum and others met to plan for Swedish royalty to attend the Swedish Pioneer Centennial celebration. From left to right are Philadelphia mayor Bernard Samuels (1941–1952), Karen Koch from Sweden, museum curator Marshall W. S. Swan, and Frank Melvin. The event commemorated the early Swedish pioneers. (Courtesy of the American Swedish Historical Museum.)

Members of the museum pose on the carpeted stairs of the richly decorated, two-story grand hall of the museum, having come together in 1948 for the Swedish Pioneer Centennial event. Architect John Nyden, a Swedish American from Chicago, designed the building to reflect both Swedish and American architectural elements. The hall on the first floor is one of the more impressive structures of the museum and the scene of many cultural events, such as the St. Lucia fest in December. (Courtesy of the American Swedish Historical Museum.)

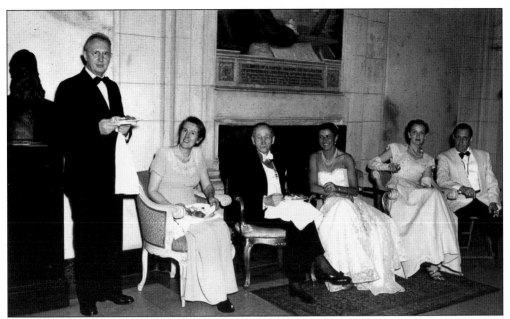

Swedish couples are shown seated in the grand foyer with Amandus Johnson (third from left) on June 6, 1948. They are pictured in front of a painting by the Swedish painter Christian von Schneidau that depicts the signing of the Declaration of Independence. The event celebrated the Swedish king's birthday. (Courtesy of the American Swedish Historical Museum.)

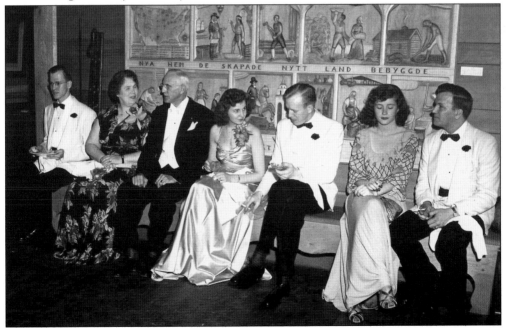

Here dancers at the king's birthday ball take a rest. Many social events are organized by the museum, making it a special place to hold ceremonies or celebrations. Seated from left to right are John Groves Richter, Sophia Moe Richter, Horace Freytag Richter, Dorothy Smith, Wallace F. Richter, Geraldine Shaw, and Christian Moe Richter. (Courtesy of the American Swedish Historical Museum.)

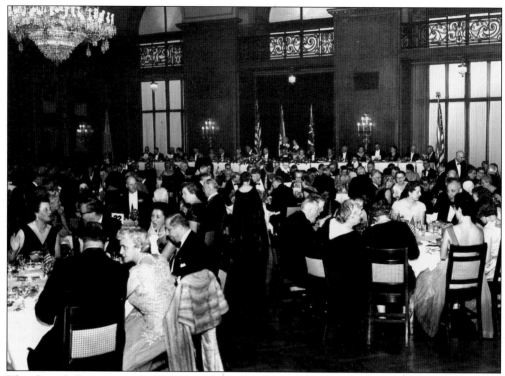

This formal dinner party held at the Union League on October 28, 1957, celebrated the 80th birthday of Amandus Johnson. Dr. Johnson was an acclaimed scholar who wrote historical works about the Swedish colonial period. He also translated a number of Swedish works into English. He was one of the founders of the Swedish Colonial Society in 1908. Dr. Johnson taught Germanic languages for many years at the University of Pennsylvania. Also shown (below) is the head table for the celebration dinner of Dr. Johnson. A large crowd of Swedish Americans came to the Union League in Philadelphia to honor a man who had done a great deal for that group of emigrants from Sweden. (Courtesy of the American Swedish Historical Museum.)

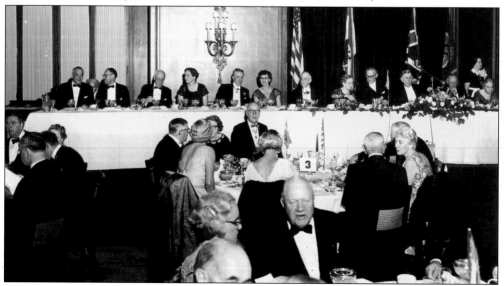

Dr. Amandus Johnson (left) greets well-wishers in the receiving line at the Union League upon the occasion of his 80th birthday. Over the years, Dr. Johnson conducted extensive research in the United States and in Europe into the Swedish American colonial period and wrote a number of books on the subject. He held many offices with the museum and was involved in an endowment campaign to celebrate the 300th anniversary of the Swedish settlement in North American. (Courtesy of the American Swedish Historical Museum.)

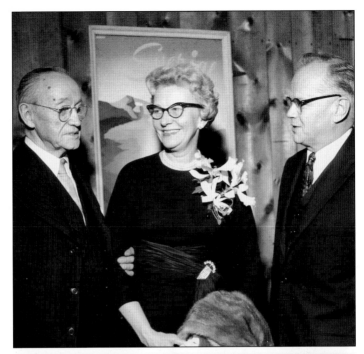

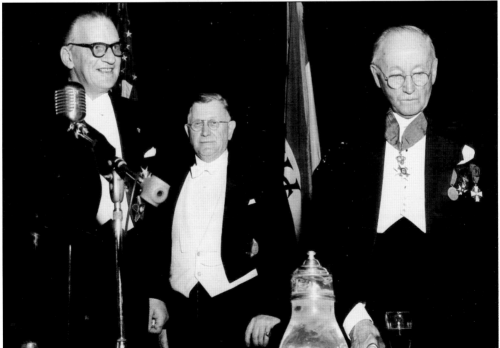

This 1957 photograph was taken at the Union League during the American Swedish Historical Museum's celebration of Amandus Johnson. Dr. Johnson is seen accepting his award for many years of service to the Swedish community on the occasion of his 80th birthday. From left to right are Swedish ambassador Erik Boheman, Dr. Samuel B. Sturgis, and Dr. Amandus Johnson. (Courtesy of the American Swedish Historical Museum.)

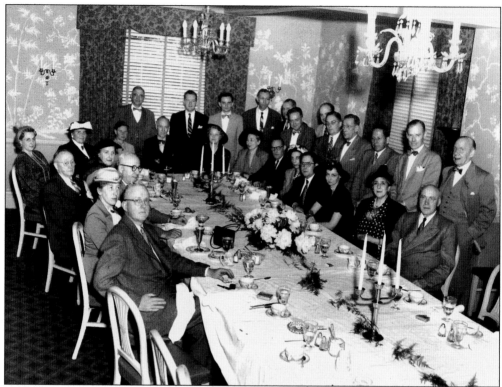

Members of the publicity committee attend a luncheon in May 1951. The committee is responsible for suggesting and organizing the many cultural, education, and artistic events held at the museum. In 1951, the museum held an exhibit of the paintings of Thorsten Lindberg. There was also an exhibition of modern Swedish glass during the same year held with the cooperation of the John Wanamaker department store. (Courtesy of the American Swedish Historical Museum.)

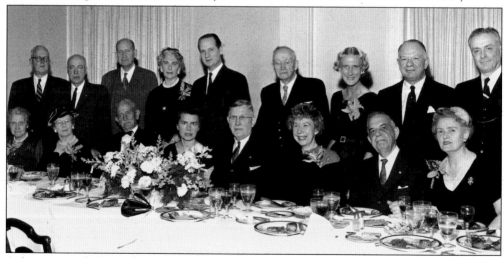

A dinner given by Dr. and Mrs. Samuel B. Sturgis at the Acorn Club in Philadelphia on November 7, 1958, was attended by members of the Swedish American community. The Acorn Club, founded by women in 1889, is a private, member-owned club. Dr. Sturgis was a physician in the Philadelphia area and very active at the museum. (Courtesy of the American Swedish Historical Museum.)

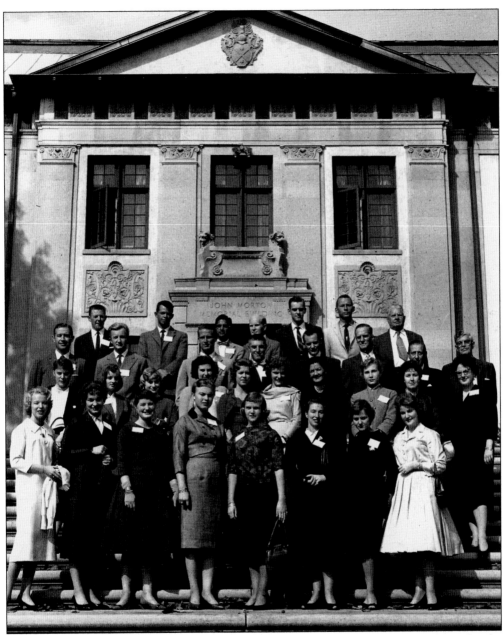

Trainee students and others are pictured on the steps of the museum at a reception for the museum trainees on October 4, 1958. In 1955, the museum instituted a program of student and trainee exchange with Sweden. This program permitted a temporary visitor in the United States to pursue trainee activities in the area of their choice. (Courtesy of the American Swedish Historical Museum.)

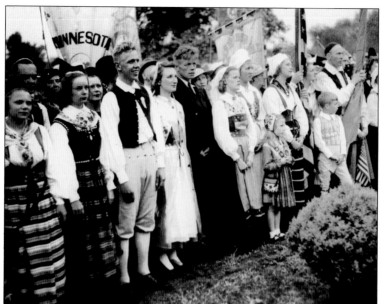

The 300th anniversary of the Swedish colony's arrival on the Delaware shores was celebrated at the museum on June 28, 1938. Shown here are students in formal Swedish dress standing before the Minnesota delegation watching the formal dedication of the museum. (Courtesy of the American Swedish Historical Museum.)

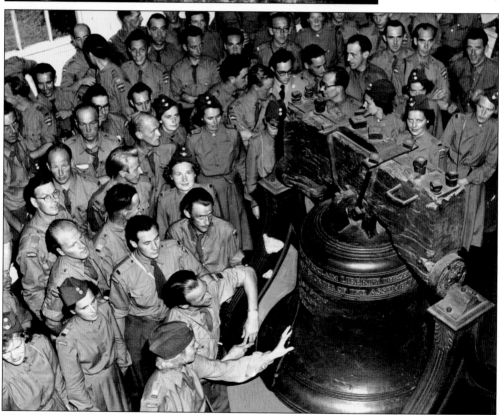

This 1950 image shows members of the Swedish Red Cross unit paying homage to freedom at the Liberty Bell in Philadelphia before they left for an assignment in Korea. Prior to their departure, they were stationed at Fort Dix, New Jersey. (Courtesy of the Urban Archives, Paley Library, Temple University.)

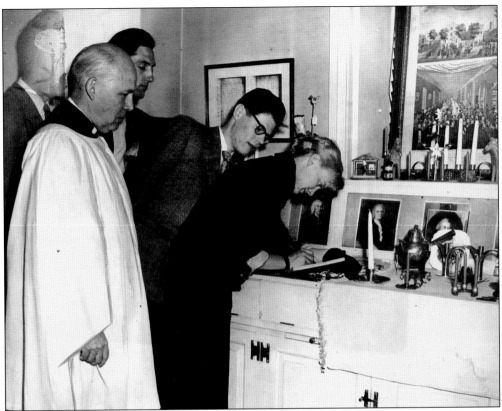

Rev. William M. Sharp (left foreground) of the Old Swedes Church stands by as Katja Walden signs the church registry on July 6, 1953. Axel Wenerholm (left background) and Lars Gullstrom are shown in the photograph; they are three of 11 young Swedes participating in the Main Line's Experiment in International Living program. (Courtesy of the Urban Archives, Paley Library, Temple University.)

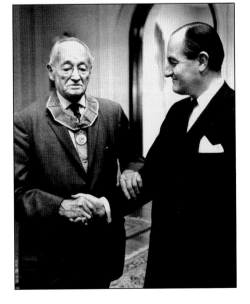

Amandus Johnson, an American historian, author, and founding curator of the American Swedish Historical Museum, is most associated with his epic two-volume history *The Swedish Settlements on the Delaware, 1638–1664.* He is shown here receiving the Royal Medal from Ambassador Hubert de Besche on March 11, 1965. (Courtesy of the American Swedish Historical Museum.)

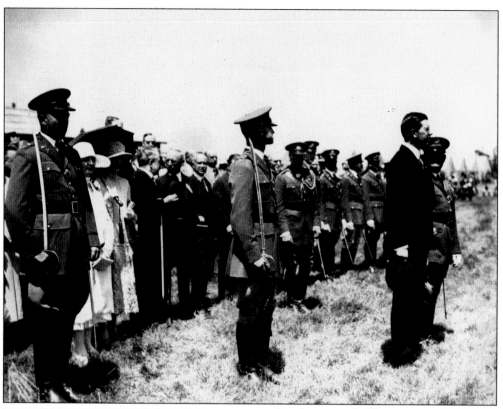

Another event held in conjunction with the ground-breaking and laying of the cornerstone of the museum was the review of the parading troops at Wicaco by the crown prince of Sweden. Wicaco was an early settlement of the Swedes and was located in what is now Queen Village in Philadelphia. (Courtesy of the American Swedish Historical Museum.)

This document dated May 20, 1926, is written in Swedish and signed by members of the American Swedish Association led by Amandus Johnson. The document signifies the laying of the cornerstone by the crown prince of Sweden in commemoration of the early Swedish colonists. (Courtesy of the American Swedish Historical Museum.)

Delaware Tercentenary

Wilmington, Delaware

★

Rooms Available For Tourists

No.	Name	Rooms No.	Persons	Price per Person	Breakfast per Person
	NORTH MARKET STREET				
811	Mr. Ariza (2nd floor)	3	6	1.50	
1215	Layton Sandstrom	1	2	2.00	
1227	Mrs. M. Freeman	1	2		
1816	Mrs. Emma Morris	1	4	1.00	
		2	3		
		3	2		
1820	Mrs. D. A. Goldsborough	1	3	2.50	
		2	2		
		3	2		
2014	Anna M. Bulifani	1	2		
		2	2		
		3	1		
2104	Mrs. Booth	2	4		No
2811	Mrs. A. B. Shonk, Apt. 12	1	2		
2812	Miss Clara Blackburn	1	2		Yes
		2	2		
2814	Mrs. Wm. H. Landing	1	2	1.50	.50
		2	2		
3111	Mrs. Frank Townsend	1	3	1.00	.35
3308	Mrs. Orchow	2	4	2.00	(Included)
3902	Mrs. Chas. A. Fox	1	2	3.00	.35
		2	2		
		3	2		
4001	Mrs. C. D. Turner	1	4	1.00	.35
		2	2		
	WEST SECOND STREET				
815	Mrs. Paul Jones	1	2	2.00	.50
		2	2		
1031	Mrs. Adamoski	1	2	1.25	
1321	Mrs. Mary Pappa	.	6	5.00	
1622	Mrs. Joseph Gannon	1	2	1.00	.50
1634	Mrs. Maryl Haley	1	2	3.00	.50
		2	2		
1717	Mrs. Estella Pass	1	2	2.50	
	THIRD STREET				
	S. W. Corner Third and Shipley Streets				
	The New Russian & Turkish Baths		30	2.00	No
	THIRD STREET				
WEST					
405	Mrs. Cramer	1	3		
	FOURTH STREET				
EAST					
331	Mrs. William Chalmers	1	2	2.00	No

Shown here is the list of rooms available for tourists in Wilmington, Delaware, for those attending the Delaware Tercentenary celebration on June 26–27, 1938. Rooms could be had, for instance, at the William H. Landing home, located at 2814 North Market Street, for $1.50 per night, per person, with breakfast for 50¢. (Courtesy of the American Swedish Historical Museum.)

The author (left); her father, Algot; and sister Dolores are on the grounds of St. Bartholomew School in Wissanoming. The school, in 1948, was a multicultural one with Swedish, Polish, Italian, and German students. (Author's collection.)

DELAWARE TERCENTENARY
BULLETIN

No. 6 June, 1938

PROGRAM *of* TERCENTENARY
CELEBRATION
WILMINGTON, DELAWARE
JUNE 26-27, 1938

(All hours indicated are according to Eastern Daylight Saving Time.
This Program is subject to change if necessary).

SUNDAY, JUNE 26

3 P. M.—Old Swedes Church
All Swedish Interdenominational Service, conducted by Rev. Julius Lincoln, D. D.
(Admission only by invitation of the Committee in charge)

7.30 P. M.—Rodney Square
Music by 198th Coast Artillery Band.

MONDAY, JUNE 27

9.30 A. M.—Fort Christina Park
Music by United States Marine Band, the Guards Military Band of Sweden and a Swedish Male Chorus.
(Because of limited space, admission to the Park for this concert and the following ceremony will be by ticket only.)

10 A. M.—Fort Christina Park
Invocation by Rt. Rev. Edvard Rodhe, Bishop of Lund, Sweden.
Ceremony of presentation by the Crown Prince of Sweden to President Roosevelt of the monument given by the people of Sweden to the people of the United States; acceptance by the President and delivery to Governor McMullen of Delaware; acceptance by Governor McMullen; presentation of medal to the President by Dr. E. Rudolf W. Holsti, Minister of Foreign Affairs of the Republic of Finland; presentation of medal to the President by Hon. Thomas F. Bayard, President of Delaware Tercentenary Commission.
(These speeches will be broadcast to Rodney Square and to the people of the United States and abroad).

11.30 A. M.—Old Swedes Church
Religious ceremony, Rt. Rev. Edvard Rodhe, D. T., Bishop of Lund, Rt. Rev. Henry St. George Tucker, D. D., Presiding Bishop of the Protestant Episcopal Church, and Rev. P. O. Bersell, D. D., President of Augustana Synod participating.
(Admission to this service will be limited to the Official Delegations from Sweden and Finland and the tourists from Sweden).

12 M.—Rodney Square
Concert by American Union of Swedish Singers.

12.30 P. M.—Delaware State Armory
Luncheon for the tourists from Sweden.

The program for the Delaware portion of the Tercentenary in Wilmington is shown at left. Events were held at Old Swedes Church, Rodney Square, and Fort Christina Park, and a luncheon for tourists from Sweden was held at the Delaware State Armory. The crown prince of Sweden also presented Pres. Franklin D. Roosevelt with a monument given by the people of Sweden to the people of the United States. (Courtesy of the American Swedish Historical Museum.)

Two

SWEDISH LOG CABINS

This country's iconic log cabin is often seen as a metaphor for the American spirit of rugged individualism. However, the log cabin is really a Swedish construction. When the Scandinavians arrived in the Delaware Valley they built sturdy, easy-to-construct cottages called *stugas*. Early log cabins were fairly easy to build: fell some trees, chop notches in the ends, stack the logs one upon the other, and cover with a sod roof.

These Swedish cabins were constructed in a very unique way. The Swedes did not use nails or wooden pegs. Instead, they notched the edges of each of the logs and fitted the logs together by hooking them at the notches. The cabin had a low-pitched roof of split logs overhead and a floor of hard-packed clay underfoot, which made it quite habitable. The open spaces between the logs were packed with mud and/or clay mixed with grass, straw, and animal hair. There were no windows in these early cabins; sliding boards between the logs were used to let in light or provide visual access to the outside. After the original cabin was built, an addition—probably to accommodate a newly married son or daughter—was often added to the east side.

While many thought the cabins ugly and crude, others realized their value, especially in the wilderness. Because of their utility, many were constructed in the Delaware Valley and other places around the country.

It is not known when stugas were first built, but they are believed to be a product of Northern Europe's bronze era. Despite the cabin's long history, many people incorrectly believe this utilitarian building was created on America's western frontier. Possibly because of its spread to the West, some historians consider the log cabin to be New Sweden's greatest contribution to the development of the New World. Very few examples of New Sweden's main structures remain today. The Lower Swedish Cabin, also called the Addingham Cabin, on Darby Creek in Drexel Hill, is one of these few and is open to the public.

Because of the work of many volunteers, today the Swedish Cabin is listed on the National Register of Historic Places and exemplifies Swedish craftsmanship.

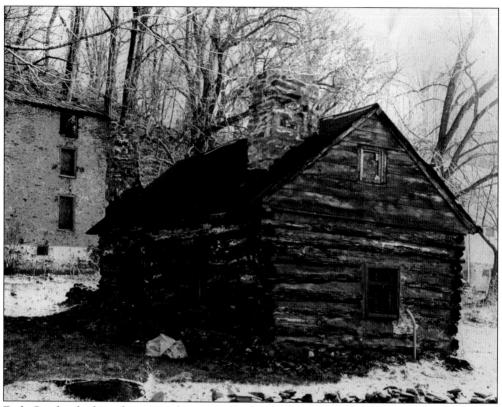

Early Swedes, looking for a new place to settle, found their way to the little spot in the shadow of the first physical obstacle to be encountered, the Great Hill (*Stor Kulle*). Rapids in the Darby Creek likely deterred further travel by canoe or dugout, so it was here that they began their building efforts. The Lower Swedish Cabin on Darby Creek, shown here in a photograph from 1937, is located just above Tinicum. (Courtesy of the Friends of the Swedish Cabin.)

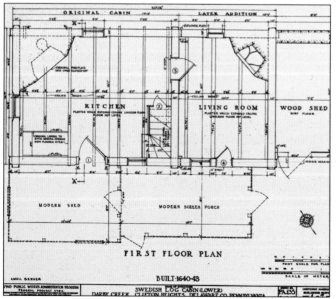

This floor plan shows the inside of the Lower Swedish Cabin. This is a typical Swedish log cabin, with the fireplace in the corner. The floor plan shows a wooden shed and a screen porch out front, both of which have been lost over the years. The section of the floor plan that indicates a "living room" was really an addition used for the family's newlyweds, also with a fireplace in the corner. (Courtesy of the Friends of the Swedish Cabin.)

The Upper Swedish Cabin, which was also called the Kellyville Cabin, burned to the ground during the 1980s. This c. 1940 photograph of the interior was taken at a time when the cabin was used as shelter by transient people. (Courtesy of the Friends of the Swedish Cabin.)

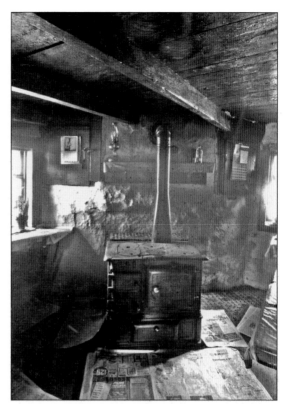

Swedish cabins such as this one, which used round logs with the bark intact, can be identified not only by how the logs were notched and joined, but also by the corner placement of fireplaces, with the chimney rising inside. The later Dutch and English homes had fireplaces along the wall, and the chimney was outside. This 1980s view of the Lower Swedish Cabin reflects the reconstruction work done by a group of volunteers from Upper Darby Township in Pennsylvania. (Courtesy of the Friends of the Swedish Cabin.)

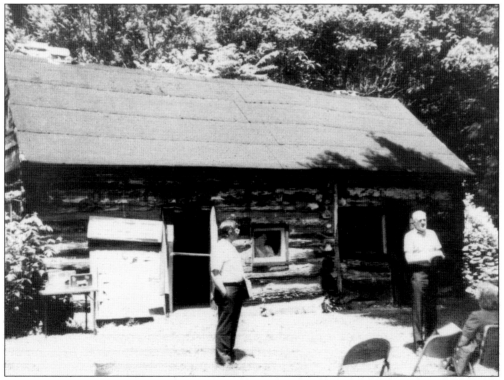

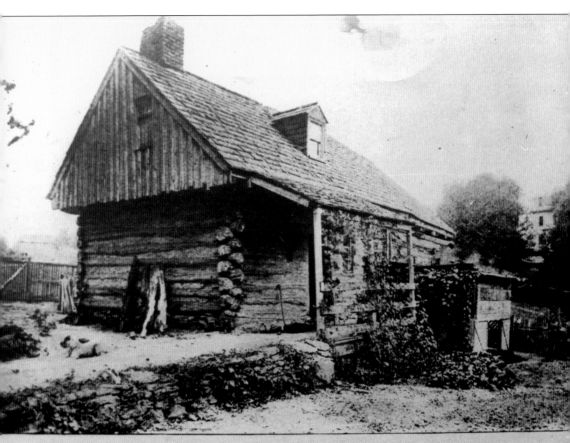

OLD HOUSE ON DARBY CREEK, NEAR CLIFTON, 1681.

The Upper Swedish Cabin, located a few miles upstream from the Lower Swedish Cabin, was demolished by fire in 1981 and was located in the area called Kellyville. This photograph, taken February 5, 1937, shows the exterior of the cabin viewed from the northwest. (Courtesy of the Library of Congress; photograph by Ian McLaughlin.)

Recalling Delaware County's movie mogul

Log cabin served as early backdrop

By BILL MURPHY
Associate Editor

Despite all of the attention the current restoration project has focused recently on Upper Darby's colonial Swedish Log Cabin, one fascinating aspect of its history is all but forgotten: its role as an early Hollywood.

Between 1898 and 1912, the cabin, along with other Delaware County locales, served as a backdrop for hundreds of short Westerns made by a man who was one of the most powerful figures in the infant motion picture business.

Siegmund Lubin was a pioneer Philadelphia-based film producer and theater chain owner. At its peak in 1912, his company was one of the largest motion picture firms in the world, providing the likes of Oliver Hardy and Marie Dressler with their first breaks in films (see accompanying story).

A German immigrant, Lubin began as an optician. Through his interest in lenses, he branched into photography and ultimately began tinkering with the new toy of the day, motion pictures. The firm's first fortune came with what was billed as a film of the landmark 1898 Corbett-Fitzsimmons fight, though it was actually filmed in Lubin's back yard in Philadelphia,

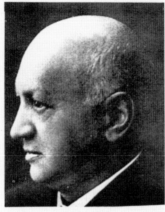

SIEGMUND LUBIN

owners.

"During lunch hours, their employees would go watch filming, and would either come back late or not come back at all," Kowall said. "The owners banded together and tried to get Lubin to go, but they were unsuccessful.

"The same thing would happen with the schools. The children were just bedazzled by what was happening."

Delaware County's brief heyday as a filmmaking capital gradually ended as the patent war with Edison began to wind down.

"A final legal solution was never really found," Kowall said. "It ended because the parties became exhausted. The next stage came when Edison, Lubin and the other giants in the industry got together and tried to squeeze out the newcomers by forming a new company."

In 1912, Lubin permanently stopped filming in Delaware County and moved to Betzwood, an enormous lot along the Schuykill in the Valley Forge area. It was the largest outdoor motion picture production complex in the world at that time. Lubin also opened studios in California, Florida, Rhode Island and Maine, though the Philadelphia area always remained the hub of his operation.

Lubin's empire was relatively short-lived. The company folded in 1916, in part becuase World War I cut off the European market for films, in part because the U.S. Supreme Court imposed staggering penalties on Edison, Lubin and the others when it disbanded their monopoly in 1915.

The Lower Swedish Cabin served as an early backdrop for Western movies made by the German-American motion picture pioneer Siegmund Lubin. A Philadelphia-based film producer and owner of a theater chain, he used the cabin for hundreds of short Westerns. Shown here is an article from the *News of Delaware County Bicentennial Guide*, September 20, 1989. (Courtesy of the Friends of the Swedish Cabin.)

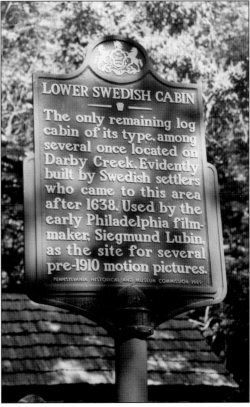

This sign on the road to the Lower Swedish Cabin notes that the cabin is the only remaining log cabin of several of its type that were once located in the Darby Creek area. The marker indicates that the area was settled in 1638 and also that the Lubin movies using the cabin were made before 1910. (Courtesy of the Friends of the Swedish Cabin.)

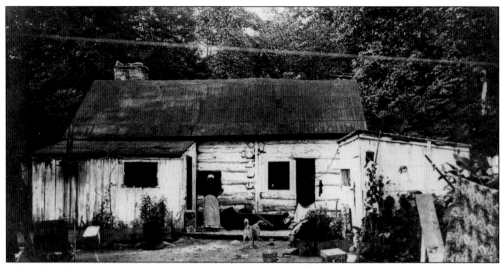

This view of the Lower Swedish Cabin, from a photograph taken in the late 1890s, shows the inhabitant of the cabin, a woman, standing near the door at the front of the house. The shed and outbuilding to the left and right were never part of the original cabin. There was, however, a base for the attached shed. The Friends of the Swedish Cabin restored the base in 2005. (Courtesy of the Friends of the Swedish Cabin.)

Valley Vistas

Inside Today:

The First Log Cabin

New Salads

A Visit with Archery Expert, Smokey Wagner.

A Look at Fall Gardens & Fall Roadways

Warren County's Weekly Magazine

STUGAN I INDIANSKOGEN —- Or, if you prefer, the cabin in the Indian woods, is a relic of the dim past. This humble log cabin was built early in the 1600's by Swedish settlers in the new World. It still stands only a short distance from the bustling city of Philadelphia, forgotten by almost everyone except those who have studied the brief history of New Sweden. Few remember that it was the early Swedish colonists who first built cabins of logs. Others who came to North America quickly realized the practicality of the sturdy structures and copied the basic design. Thus it was that the 12th president of the United States was born in a home patterned after a frontier "stuga" built in 1638. See

This article, from as far away as Warren County, Pennsylvania, describes the Lower Swedish Cabin, calling it the *stugan I indianskogen* (Cabin in the Indian Woods). The article was published in Warren County's weekly magazine, *The Valley Vistas*, issued by the *Valley Voice Newspaper*. (Courtesy of the Friends of the Swedish Cabin.)

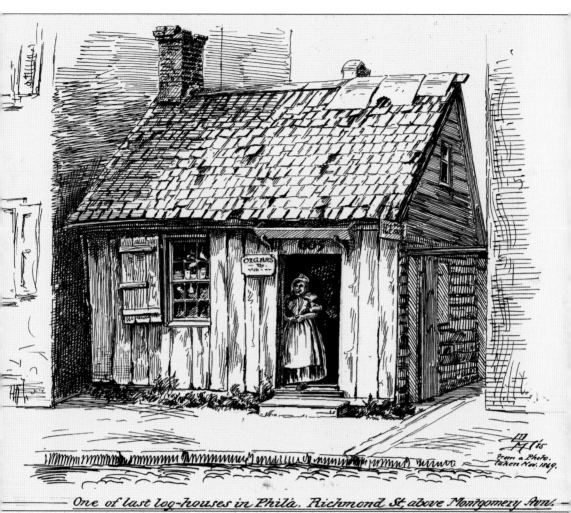

Shown here is another log cabin, this one located on Richmond Street, above Montgomery Avenue in the Port Richmond section of the city. This is a sketch of the former cabin, and it is considered a depiction of one of the last cabins in that area. A woman is standing in the doorway, and a sign on the side of the building advertises cigars. (Courtesy of the Print and Picture Department, Free Library of Philadelphia.)

Grace Conran, president of Friends of the Swedish Cabin, and Walter Evans, a member, dressed as Swedish pioneers for an enactment ceremony in the 1990s. The Lower Cabin frequently holds Swedish-related activities and events, such as enactments and pea soup suppers, a typical winter dinner in Sweden and the New Colony. (Courtesy of the Friends of the Swedish Cabin.)

This Bible, written in Swedish, is a prized artifact belonging to the Friends of the Swedish Cabin. The Bible dates from the 1890s and is only displayed at the cabin during special events and ceremonies. A Bible was a family's most valued possession and would have been one of the very few items brought along on the sea voyage from Sweden, as space was limited. (Courtesy of the Friends of the Swedish Cabin.)

A Certificate of Appreciation

The Township of Upper Darby Pa, Hon. James J. Ward and The Friends of The Swedish Cabin gratefully acknowledge the help of _Mr. & Mrs. Thomas Doyle esq._ in the historic restoration of one of America's oldest dwellings,

The Lower Swedish Cabin, circa 1654

James J. Ward, Mayor
The Township of Upper Darby

George Ambrose, President
The Friends of the Swedish Cab

This certificate of appreciation was presented by the Friends of the Swedish Cabin and the Township of Upper Darby to the Doyle family for their efforts in the historical restoration of the Lower Swedish Cabin. The Doyles lived in a large 1800s house next to the Lower Swedish Cabin; the property is now owned by the township, which plans to preserve it as green space. (Courtesy of the Friends of the Swedish Cabin.)

This document, signed August 23, 1937, lists the details of the Lower Swedish Cabin and indicates that the building was built between 1643 and 1653 by one of the area's Swedish settlers. This makes the structure one of the oldest in the country. The document indicates that the building is in good but altered condition. (Courtesy of the Friends of the Swedish Cabin.)

```
              UPPER SWEDISH LOG CABIN
        West Bank of Darby Creek - about 450
       yards above Clifton Station located
               Upper Darby Township
               Delaware County, Penna.

        _____

Owner   -  ?

Date of Erection  -  1643 - 53

Architects - Unknown

Builder  -  Unknown

Present Condition -  Good, although much altered.

Number of Stories -  One and one-half stories.

Materials of Construction - Log cabin construction, wood
frames and sash.  The present brick chimney is a later
addition.  The interior has been so much renovated that
little of the original construction is visible.

History - This building is said to have been built between
1643 and 1653 by a Swede.  It remained in its original
condition until at least 1908, which is proved by a photo-
graph of the exterior reproduced in  Paxson's "Where Pennsylvani
History Began".

Bibliography - Paxson's "Where Pennsylvania History Began".
               (Henry D.)

                                   August 23rd, 1937

                                  Joseph P. Sims
                             Joseph P. Sims, A.I.A.
                             District Officer
```

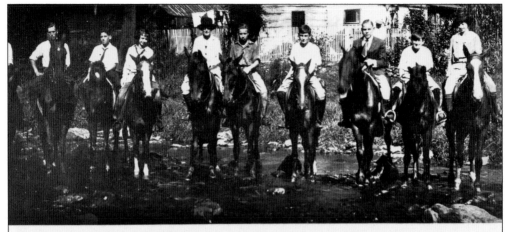

Drexel Hill Riding School - c. 1916

After traveling the riding path down Sharkey's Hill to the Swedish Cabin (seen in the background) on Darby Creek, Mrs. Hasselman (center in the black hat) pauses with her riding students. For generations, horseback riding was almost a necessity, but with the advent of the horseless carriage and other means of transportation, it became a luxury with riding schools giving paid lessons. Although Mrs. Hasselman's horses were stabled in a barn at Lasher Road and Childs Avenue, her school was located at 329 Burmont Road, presently an empty lot. The insert is Mrs. Hasselman's ad placed in the dedication book for the Upper Darby Municipal Building at its opening celebration in 1930.

Rebecca Hasselman (center, in black hat), shown here in 1916 with members of her Drexel Hill Riding School, found it good for her business to make the trail to the cabin a known part of her riding tour. Her school was located at the top of Lasher Road in Upper Darby. The cabin was visited increasingly after 1900 by locals and visitors seeking the cooling air of the creek in summer. (Courtesy of Thomas R. Smith and the Friends of the Swedish Cabin.)

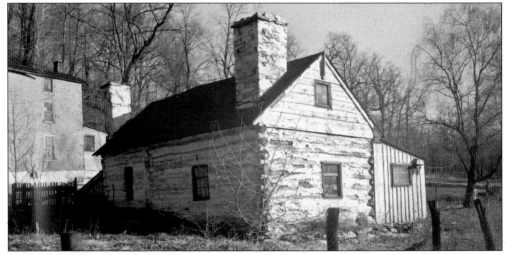

The upper two stories of the mill house, shown in the background (left) in this view of the Lower Swedish Cabin, have since fallen, but part of the first story remains. According to Delaware Valley historian Thomas R. Smith, the cabin was occupied in the 1880s by the Evan brothers, a pair whose connection to traveling shows may have encouraged them to promote fascination with the cabin. The two brothers worked as laborers for Buffalo Bill Cody's Wild West shows. When the men retired, they came back to Pennsylvania and settled at the cabin—a place where they could reconnect to the past. The cabin was visited increasingly after 1900 by locals who were looking for fresh country eggs from the brothers' chicken farm. (Courtesy of Thomas R. Smith and the Friends of the Swedish Cabin.)

An old mill located close to the Lower Swedish Cabin in Delaware County is shown in this photograph from the 1850s. The abundance of streams and creeks in the area encouraged the establishment of the mill trade, which greatly increased the population of Upper Darby. At one point in the 1800s, the population of Upper Darby increased from about 800 to almost 5,000 by the 1890s. It is possible that this mill is the one shown on page 40. (Courtesy of the Print and Picture Department, Free Library of Philadelphia.)

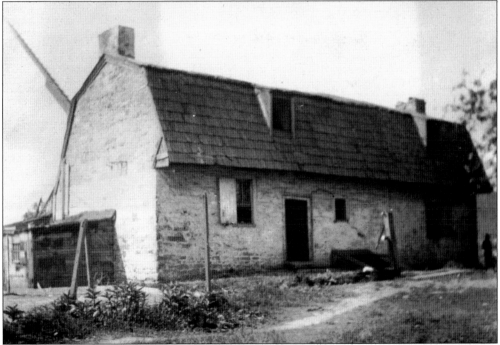

The Hendrickson House was moved from Ridley Township to the site of Old Swedes Church in Wilmington, Delaware, and reconstructed. This house is a unique example of a Swedish colonial home, much more elaborate than the Swedish log cabins. This was the home of Andrew Hendrickson and his wife, Brigitta Morton. Both were born in New Sweden. This 1900 photograph was taken in Ridley Township. (Courtesy of the Old Swedes Foundation.)

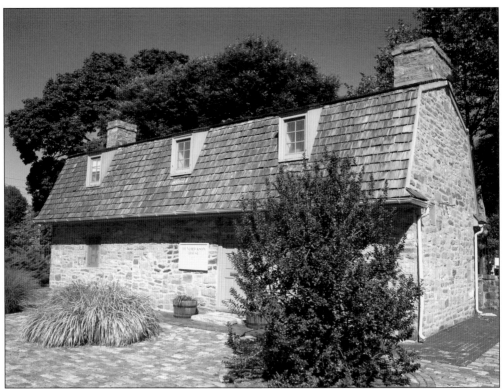

This is the Hendrickson House as it appears today on the grounds of Wilmington's Old Swedes Church. After the home was moved to its new location, it commemorated the rebuilding and opening of the home as a historical building of early Swedish construction. (Author's collection; photograph by Klaus Krippendorff.)

The huge Boeing complex in Ridley Township was once the site of the Hendrickson House. The property was situated on the Delaware River and was a large plantation owned by the Hendricksons for many years. (A map of the site is shown on page 123.) (Author's collection; photograph by Klaus Krippendorff.)

Three

SWEDISH IMMIGRANTS AND THEIR NEIGHBORHOODS

According to the 1890 U.S. Census records, Swedish emigration during the 19th and 20th centuries resulted in more than 800,000 people coming to these shores. During this time, Sweden was a repressive society, and many were unhappy with their country's social conservatism as well as being under the rule of the Swedish monarchy. Many settled in the American Midwest, perhaps finding a climate and terrain similar to Sweden's. But many coming through Ellis Island in New York settled on the East Coast, especially in Pennsylvania and New Jersey.

Many of these immigrants had been well educated in Sweden through the Lutheran Church, and so, while poor, these Swedes were able to find work and improve their lot in life. They left Sweden from Gothenburg but had to first travel through either Liverpool or Glasgow before arriving in New York. The journey was long and hard, but the rewards were great for these families who were looking for a better quality of life.

A common conception of the Swedish immigrant is of a hardworking and diligent farmer, but the reality is that many were factory workers. Many looked for work in the big cities of the United States—New York, Philadelphia, Chicago, and Minneapolis-St. Paul—where more opportunities were available to them. Here in the Delaware Valley, there were a number of Swedish neighborhoods, such as Ridley, Queen Village, Wissinoming, and Tacony. While some immigrants clung to their Swedish language and had difficulty learning English, many embraced the new language, and in many homes Swedish was not allowed to be spoken. In families determined to become Americanized, it was only the parents who spoke Swedish and only between themselves. The children, who in many cases had to enter school immediately, had no choice but to learn the English language.

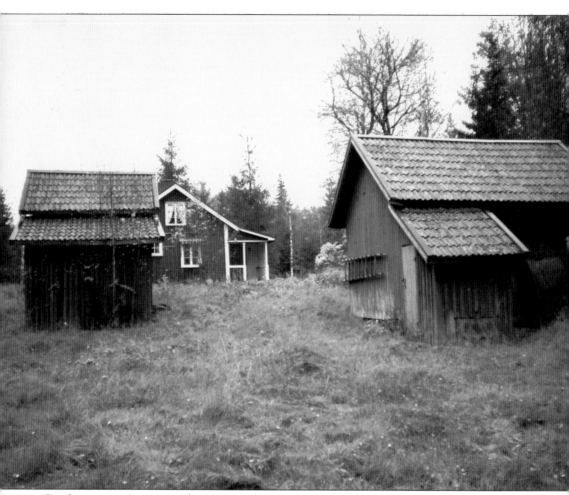

Swedes came to America in droves as conditions worsened in Sweden. Because of industrialization, famine, and general unrest in Sweden from 1870 through 1910, more than one million Swedes immigrated to this country. The Olssen family homestead in Bjarn, Karlanda Parish, Värmland, Sweden is shown here. The author's great-grandfather lived on this farmstead until he immigrated to Norway. (Author's collection.)

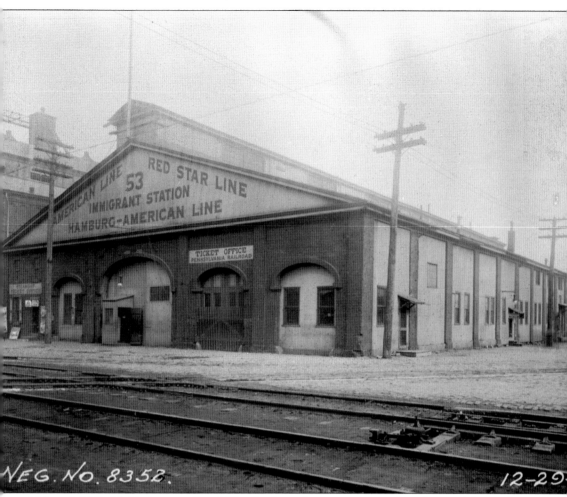

AMERICAN LINE
RED STAR LINE
53
IMMIGRANT STATION
HAMBURG-AMERICAN LINE

TICKET OFFICE
PENNSYLVANIA RAILROAD

NEG. NO. 8352.

12-29

Although Philadelphia is more than 100 miles from the ocean, it served as the port of entry for many immigrants from 1815 to 1985. Washington Avenue Immigrant Station, the first immigration station built by the Pennsylvania Railroad, was erected in the 1870s and was located on a pier at Washington Avenue and the Delaware River. This station was demolished in 1915. (Courtesy of *Philly*History.org, a project of the Philadelphia Department of Records.)

The U.S. immigration station in Gloucester City, New Jersey, was a large, converted Victorian house on South King Street in an industrial area across the Delaware River from Philadelphia. It was not only an immigration center, but also a detention center for female immigrants. Many Swedes who emigrated from Sweden came to the Delaware Valley from this station. (Courtesy of *Philly*History.org, a project of the Philadelphia Department of Records.)

Photographer John Moran (1839–1914) took this photograph looking west on Christian Street between Front and Water Streets around 1865. These Swedish houses are built on an unpaved street, with streetlamps on the sidewalk. Now called Queen Village, this area was then known as Southwark— the name given by William Penn to "New Sweden," a small community of Swedish settlers who had arrived in 1642. (Courtesy of the Print and Picture Collection, Free Library of Philadelphia and the Queen Village Neighborhood Association.)

Queen Street, shown here in 1856, and the area of Queen Village are named after Queen Christina of Sweden. The area was originally owned by the Swedish family of Sven, whose log house stood on a knoll overlooking the river at what is now the northwest corner of Beck and Swanson Streets. The street sign for Queen Street is still visible in the Queen Village section of the city. Many streets in the Delaware Valley are named after the early Swedish settlers, such as Swanson Street and Governor Printz Boulevard. (Courtesy of *Philly*History.org, a project of the Philadelphia Department of Records.)

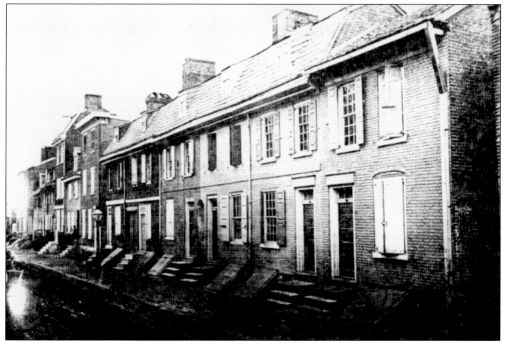

Surströmming, the infamous fermented Baltic herring, is a Swedish delicacy. The smell is so horrible that the pressurized can must be opened outside under running water. Banning it in the European Union is being considered, much to the consternation of Swedes all over the world. The process of fermenting the herring was started centuries ago as a way of preserving the fish. (Author's collection; photograph by Klaus Krippendorff.)

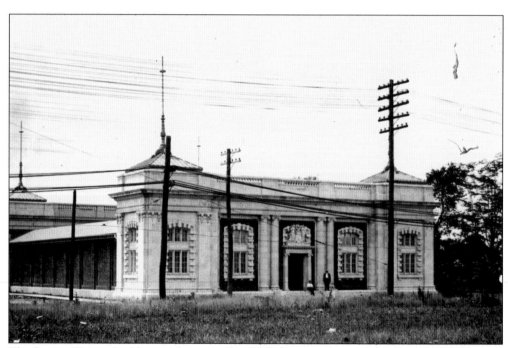

The famous Tacony bathhouse, shown in this 1935 photograph, was located on the bank of the Delaware River and was a frequent summer haunt of the children and adults of the Swedish community in Wissinoming. The bathhouse was a little more interesting than a swimming pool, with its marble floors and walls and enclosed area for bathing. (Courtesy of the Urban Archives, Temple University.)

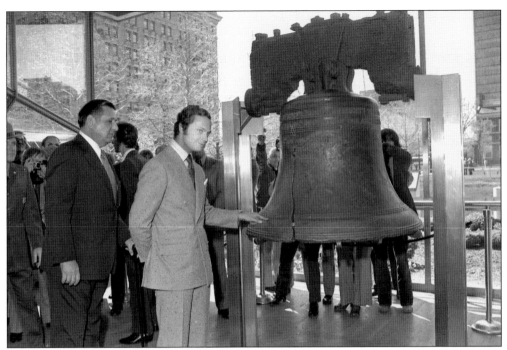

King Carl XVI Gustaf of Sweden is greeted by Philadelphia mayor Frank Rizzo on April 7, 1967. The king was on a 14-day tour of the United States that took him to the Swedish American Historical Museum luncheon at the Bellevue-Stratford Hotel and the Liberty Bell at Independence Hall, seen here. (Courtesy of *Philly*History.org, a project of the Philadelphia Department of Records.)

Wissinoming, a Scandinavian enclave in northeast Philadelphia, was a bustling neighborhood. Shown here in a 1936 photograph is Torresdale Avenue, the main street of the neighborhood where everyone did their shopping. The name comes probably from the Native American word *quissinuminck* (an early branch of the Frankford Creek) or *wissachgaman* (a place where grapes are). (Courtesy of the Urban Archives, Temple University.)

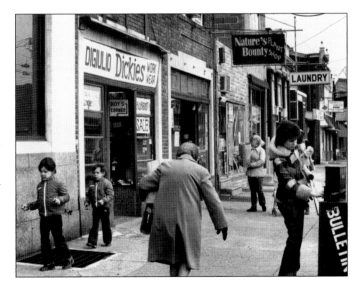

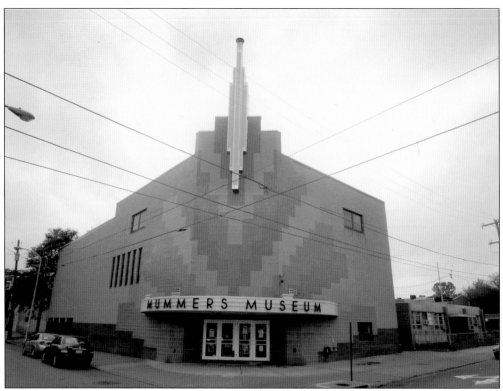

The famous Philadelphia Mummers parade had its origins with the Swedes. When the early Swedish settlers came to Tinicum, just outside of Philadelphia, they brought their custom of visiting friends on December 26, known as *Annandagjul* (Second Day of Christmas). They extended the period of their calls to the New Year, which was marked by revelry and noise. Armed Swedish masqueraders paraded the streets, carrying pistols for protection along with their bells and sundry noisemakers. (Author's collection; photograph by Klaus Krippendorff.)

PIANIST

ANNA WALLIN

OF

Royal Conservatory

Stockholm,

Sweden

Soloist at the World's Fair

Chicago 1893

Accompanist

The system applied in teaching is the most thorough and superior in technical training, embracing the fundamental elements of music, viz: touch, interpretation, musical taste and cultivation. Classic and Modern Composers studied.

Special course in instrumental sight reading and the art of accompanying.

TERMS

Ten Weeks

| Two lessons per week | . | . | $30.00 |
| One " " " | . | . | 20.00 |

Lessons missed by pupils charged for, except in cases of protracted illness

Anna Wallin, born in 1827, came to the United States from Sweden in 1889. She became a citizen in 1897 at the age of 25. She was educated at the Royal Conservatory in Stockholm. Once in Philadelphia, she provided music lessons in piano and voice in her home. From her scrapbook is her card with her fees and a description of her services. (Courtesy of the Pennsylvania Historical Society.)

Shown here is a musical program, with Anna Wallin performing "Elverhoi," a symphonic poem written in 1939 by Dutch composer Johan Wagenaar. The date of this presentation is unknown. (Courtesy of the Pennsylvania Historical Society.)

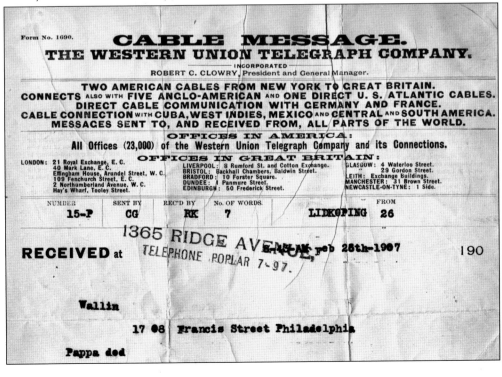

PROGRAM

1. a. "Lärkan Slår i Skyn" . *Lindblad*
 b. Brudefärden i Hardanger . *Kjerulf*
 The Swedish-American Vocal Trio

2. Ballade "Sången" . *Pacius*
 Miss Selma Linde

3. Aria fr. "Lakme" . *Delibes*
 Miss May Corine

4. Children's Songs
 a. Kantareller . *H. Palm*
 b. Lilla Gull . " "
 c. More Malena . " "
 d. Snösparfven (recitation) *Sehlstedt*
 e. Maskroser . *H. Palm*
 Miss Viola Uddgren

5. Elverhöi (Piano) *Kuhlau*
 Miss Anna Rosenqvist Wallin

6. a. Aftonwater . *Old Scotch*
 b. Drömmen . *Lindblad*
 The Swedish-American Vocal Trio

7. a. Ro, Ro, ögonsten . *Sjögren*
 b. Skal vi vandre en stund *Bäcker - Gröndahl*
 Miss Judith Lindblom

8. a. Barcarolle fr. "Tales of Hoffmann" *Offenbach*
 b. Manola . *Puget*
 Miss May Corine and Miss Judith Lindblom

9. Children's Songs
 a. Moster Lotta b. Latmasken
 c. Mor Kjasa Rulta och hennes Cat.
 Musikaliskt Skämt i 7 afdelningar *Ivar Hallström*
 Miss Viola Uddgren

10. a. Wallgossen's Visa . *Giejer*
 b. Og Raeven Log . *Kjerulf*
 Miss May Corine

11. a. Öfver skogen öfver Sjön *Lindblad*
 b. Spanish Students . *Lacome*
 The Swedish-American Vocal Trio

Miss M. Austin, Accompanist

Most of Anna Wallin's family remained in Sweden. On February 25, 1907, she received a cable message from Sweden with devastating news: her father had died. Despite her distance from her home country, Wallin remained active in Swedish affairs. (Courtesy of the Pennsylvania Historical Society.)

Form No. 1690.

CABLE MESSAGE.
THE WESTERN UNION TELEGRAPH COMPANY.
INCORPORATED
ROBERT C. CLOWRY, President and General Manager.

TWO AMERICAN CABLES FROM NEW YORK TO GREAT BRITAIN.
CONNECTS ALSO WITH **FIVE ANGLO-AMERICAN** AND **ONE DIRECT U. S. ATLANTIC CABLES.**
DIRECT CABLE COMMUNICATION WITH GERMANY AND FRANCE.
CABLE CONNECTION WITH **CUBA, WEST INDIES, MEXICO** AND **CENTRAL** AND **SOUTH AMERICA.**
MESSAGES SENT TO, AND RECEIVED FROM, ALL PARTS OF THE WORLD.

OFFICES IN AMERICA:
All Offices (23,000) of the Western Union Telegraph Company and its Connections.

OFFICES IN GREAT BRITAIN:

LONDON: 21 Royal Exchange, E.C.
40 Mark Lane, E.C.
Effingham House, Arundel Street, W. C.
109 Fenchurch Street, E. C.
2 Northumberland Avenue, W. C.
Hay's Wharf, Tooley Street.

LIVERPOOL: 8 Rumford St. and Cotton Exchange.
BRISTOL: Backhall Chambers, Baldwin Street.
BRADFORD: 10 Forster Square.
DUNDEE: 1 Panmure Street.
EDINBURGH: 50 Frederick Street.

GLASGOW: 4 Waterloo Street.
29 Gordon Street.
LEITH: Exchange Buildings.
MANCHESTER: 31 Brown Street.
NEWCASTLE-ON-TYNE: 1 Side.

NUMBER	SENT BY	REC'D BY	No. OF WORDS	FROM
15-P	CG	RK	7	LIDKÖPING 26

1365 RIDGE AVENUE,

RECEIVED at TELEPHONE POPLAR 7-97. Feb 25th-1907 190

Wallin

17 08 Francis Street Philadelphia

Pappa död

51

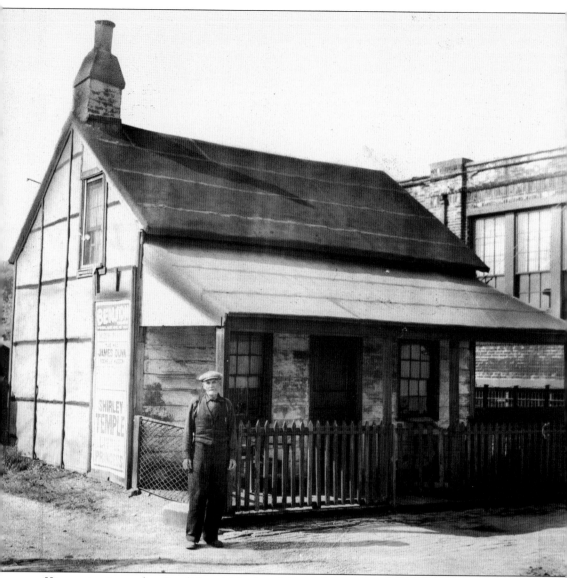

Kingsessing is another Swedish neighborhood, located in southwest Philadelphia, and is shown here in a photograph taken on June 16, 1939. The house was located at 5900 Woodland Avenue, and the image shows the exterior of a cedar clapboard house that was supposedly built by Swedish settlers in the late 17th century. (Courtesy of Urban Archives, Temple University.)

Another emigrant from Sweden was Hanna Olessen. Hanna came to the United States from Christiania (Oslo), Norway. She arrived two years after her husband, who had come ahead of her, leaving her in Norway with two young daughters. Hanna's family originally came from Värmland, Sweden. (Author's collection.)

Algot F. Thorell Sr. immigrated to the United States from Christiania (Oslo), Norway. Originally from the Gothenburg area of Sweden, he came to this country in 1907, leaving behind his wife and two children. He came to the United States so that he could provide for his family. (Author's collection.)

The Thorell family eventually bought a house at 4228 North Syndenham Street, in Nicetown, where several other Swedish families lived. Shown here in a 1912 photograph are, from left to right, Ruth, Alice, Hanna with Algot Jr. on her lap, Algot Sr., Carl, and Astrid. Alice would die a few years later from influenza. (Author's collection.)

Treaty Elm Park was situated in an area then known as Shackamaxon. The original Swedish settlers and the English who followed adopted the Lenape name for this place, which is assumed to have been derived from *schachamesink*, meaning "place of eels." This area was one of the largest Lenape settlements, encompassing the current neighborhoods of Kensington, Fishtown, and Port Richmond. (Courtesy of *Philly*History.org, a project of the Philadelphia Department of Records.)

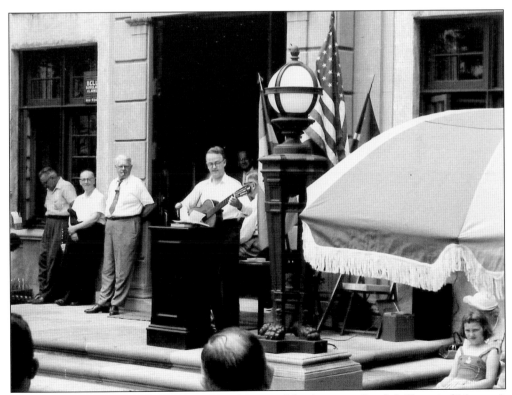

On June 16, 1956, amateur musicians gathered at one of the American Swedish Historical Museum's summer fetes on the front steps of the museum. The museum hosted annual events and those interested in Swedish culture would come to the museum from all over the country, not just from the Delaware Valley. (Courtesy of the American Swedish Historical Museum.)

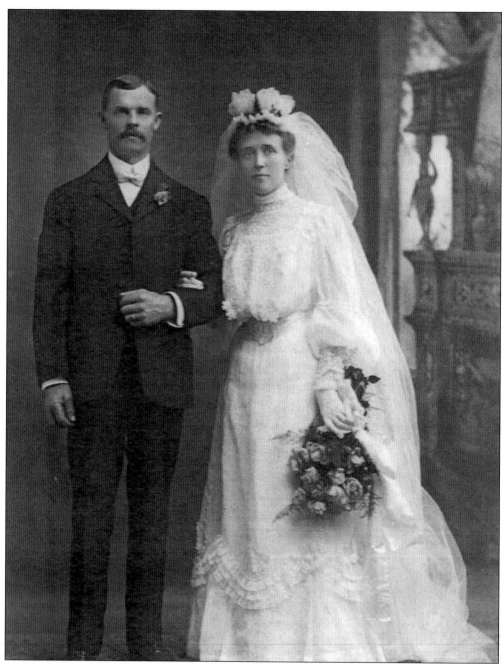

This wedding picture of Alfreda V. Carlsson and Severin Johnson was taken on October 11, 1905, in Wilkes-Barre, Pennsylvania. Five-year-old Alfreda came to America from Sweden in 1884 with her mother, Magdalena Carlsson, and four siblings. Severin came through the Delaware Valley and settled in Wilkes Barre, where he worked in the mines with other Swedish immigrants. (Courtesy of Kristina O'Doherty.)

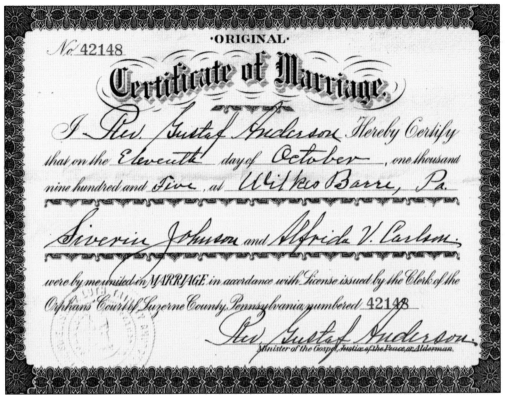

The Johnsons' marriage certificate, shown here in English but originally written in Swedish, may have been a gift from the church. The certificate of marriage (no. 42148) was signed by Rev. Gustaf Anderson and was issued by the clerk of the Orphans Court of Luzerne County, Pennsylvania. (Courtesy of Kristina O'Doherty.)

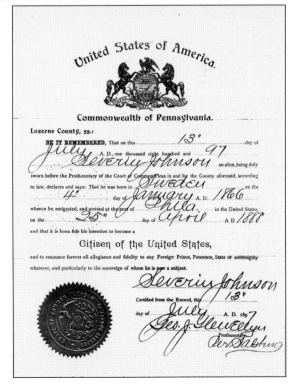

Here is a copy of the citizenship papers for Servern Johnson, who entered the United States through New York. He settled in a mining town in Pennsylvania, where he worked for many years as a miner, and became a citizen on July 13, 1897. (Courtesy of Kristina O'Doherty.)

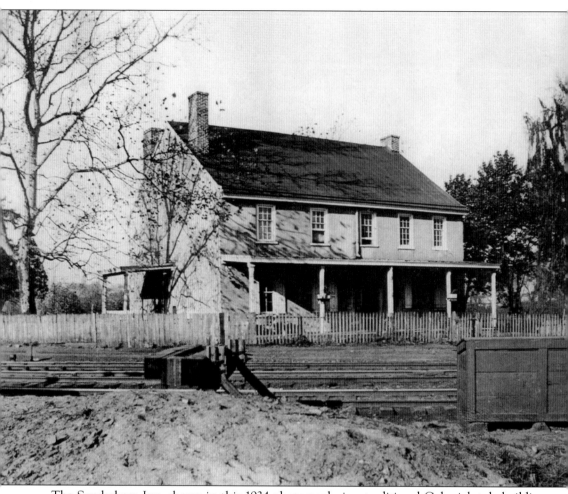

The Swedesboro Inn, shown in this 1934 photograph, is a traditional Colonial-style building constructed in 1771. Originally licensed as a tavern, the ownership of the building changed many times through the 1800s and 1900s. For many years, the inn was known as the Washington Tavern. (Courtesy of the Print and Picture Department, Library of Philadelphia.)

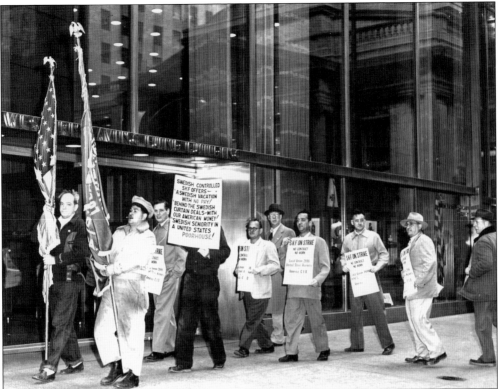

On October 28, 1952, Swedish workers from the Swedish SKF plant picketed in front of the Swedish consulate, which was at the time located at Chestnut and Broad Street. (Courtesy of the Library of Congress; photograph by Charles T. Higgins.)

Here is a June 1930 advertisement for SKF bearings. The ad shows that these bearings "are on this, the largest airplane in the world." This "giant" plane, shown, is the new German 100-passenger plane. The ad stresses the safety of the plane and its passengers because of the SKF products used in the plane. (Courtesy of the Library of Congress and SKF Industries.)

1638　　　1938

State Banquet
Commemorating the
Three Hundredth Anniversary
of the foundation of
Pennsylvania Civilization

June twenty-eighth
nineteen hundred thirty-eight
Benjamin Franklin Hotel
Philadelphia

Shown here is the first page of the formal invitation for the 300th anniversary celebration of the arrival of the first Swedish and Finnish settlers to the Delaware Valley. The event was held on June 28, 1938, at the Benjamin Franklin Hotel. (Courtesy of the American Swedish Historical Museum.)

Here is the second page of the formal invitation showing the flags of Finland, the United States, and Sweden. The program welcomes the crown prince and princess of Sweden, as well as the Royal New Sweden and Finnish Tercentenary Commissions. (Courtesy of the American Swedish Historical Museum.)

THE COMMONWEALTH OF PENNSYLVANIA

WELCOMES

THEIR ROYAL HIGHNESSES
THE CROWN PRINCE AND CROWN PRINCESS OF SWEDEN

THE ROYAL NEW SWEDEN TERCENTENARY COMMISSION

HIS EXCELLENCY, DOCTOR E. RUDOLF W. HOLSTI
MINISTER OF FOREIGN AFFAIRS OF FINLAND

THE FINNISH TERCENTENARY COMMISSION

ON THE OCCASION OF THE COMMEMORATION OF THE

THREE HUNDREDTH ANNIVERSARY

OF THE FOUNDATION OF PENNSYLVANIA CIVILIZATION

AND OF THE FIRST CHURCHES, FIRST SCHOOLS

AND FIRST LAW COURTS

Four

CHURCHES AND ASSOCIATIONS

From church groups to social organizations, historical and research societies, musical and arts associations, and even a rowing club, Swedish associations and churches made a huge difference in the life of many Swedish immigrants. The Swedes coming to the United States, while wanting to assimilate, still needed help and support. They initially used the Lutheran church to create networks and societies that aided them in finding jobs and homes and helped create opportunities for social events.

Large-scale immigration started in the mid-19th century and continued into the 1920s. By 1887, the U.S. census reported nearly 800,000 Swedes living in the United States. Many of these were farmers who had to be trained in other occupations in order to find work in the cities. Many hoped to work in factories and on construction sites in order to save enough money to buy farms in the Midwest. However, as often as not they stayed in the large cities like New York, Chicago, and Philadelphia. Many came with their families, but a large group of these Swedes were young women who took jobs as maids and domestic workers, often living with the families they worked for.

There are many organizations across the nation that helped in the early years of immigration to socialize new Swedes to the American culture. The oldest Scandinavian historical society in the United States today is the Swedish Colonial Society, which was established in 1908. The society still meets at the Gloria Dei Church in Philadelphia. Another national brotherhood society is the Vasa Order of America, a Swedish American fraternal organization founded in 1896 to provide ethnic camaraderie and social services. The organization provided health insurance and death subsidies, as well as helping people stay connected to other organizations in Sweden. The churches in each community and neighborhood also helped the new arrivals to keep in touch with their roots and to become productive in the New World.

English classes were provided because many of these Swedes were literate and intelligent. They learned English fairly early (and had an understanding of English even before them came to America). Because they were bilingual, many Swedish communities in the United States dropped Swedish altogether. But many continued, into the present day, to want to be affiliated with a Swedish or a Swedish American association of some kind, be it their Lutheran church identity or other groups.

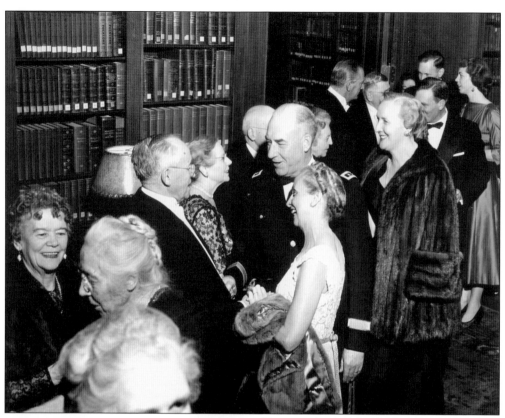

Here members of the American Swedish Historical Museum attend an event at the museum's Nord Library in the fall of 1957. The guests are being received by Dr. Amandus Johnson. The shelves are made of lacquered birch and the chairs and tables are beech wood. Subjects include books on the New Sweden colony, Queen Christina, Swedish art, 19th-century immigration, and genealogy. (Courtesy of the American Swedish Historical Museum.)

This 1959 photograph was taken at the American Swedish Historical Museum at an event when members of the Swedish Colonial Society honored Elmer W. Engstrom (at left). He was an engineer and author who wrote, among other things, *The Challenging Frontiers of Electronics*. He was also a former president of RCA. (Courtesy of the American Swedish Historical Museum.)

Stiftarna voro åtta. I juni 1884 hade klubben 22 medlemmar, därav 15 goda roddare, resten passiva. Genom hårt arbete och sparsamhet kunde vi snart nog inköpa en 6-årad gigg, den snabbaste på floden, och den döptes till "Svea". Vår rodduniform var gul och blårandig tröja, blå knäbyxor, mössa med gul stjärna i blått. Flagga och vimpel hade vi fått från Sverige, sydda av Rozyckis syster. På årbladen var en gul stjärna i blått fält. Båthus fingo vi dela med en äldre amerikansk klubb "The Riverside Club", där vi även voro medlemmar och delvis funktionärer. Alla manövrer utfördes reglementsenligt och start och tillägg gick med kläm och en stil, som ej var vanlig i det fria, jag borde säga "lediga" Amerika.

Giggen "Svea", tillhörande Svenska Roddklubben i Filadelfia. Foto omkring 1885

En härligare plats för rodd har väl aldrig funnits. Skuylkill River, som skiljer West Philadelphia från den övriga staden, gick under en sträcka av 5 miles genom den storartade och natursköna Fairmount Park. Vid parkens början lågo en mängd båthus och nedanför dem var floden uppdämd och en liten sluss förde ned till nedre Skuylkill. Ovanför slussen var därför lugnt och fint och lagom vatten och där fanns en roddbana på 4 ½ miles, som var av första ordningen.

Vid bortre ändan av banan låg ett utvärdshus "Wissahickon", som var ett mål för de mindre roddturerna, men genom att slussa ned för floden, kom man efter 5 miles till Point Breeze, där förfriskningar kunde erhållas, och efter ytterligare 3 miles var man på den stora Delawarefloden. Upp eller ned för floden funnos otaliga ställen, som voro värda ett besök. Det var egentligen först 1884, som vi voro riktigt färdigrustade. Vi hade då förutom giggen "Svea" en 4-årad utriggare "Göta" och en single scull "Thule".

Nästan varje söndag under den hyggliga årstiden gjordes långa utflykter vanligen genom slussen Point Breeze, där svenska fartyg ofta lågo och lastade och ombord på vilka vi alltid voro särdeles välkomna. Vidare nedför Delaware med strandhugg och äventyr av varjehanda slag. Egendomligt var, att vi kunde motstå sommarvärmen mycket bättre än amerikanarna. Philadelphia är känd som den varmaste staden i U. S. A., och det hände aldrig att amerikanarna gåvo sig ut på rodd under extra varma dagar, men intet väder avskräckte oss och vi gjorde 30 miles rodder på dagar, då tiotals människor stupade av solsting på stadens gator.

35

In his rowing blog, Göran R. Buckhorn calls the Swedish Rowing Club of Philadelphia a footnote of rowing history. These Swedish American rowers loved rowing long distances through Point Breeze and down the Delaware River. Founded in October 1882, the rowing club shared a boathouse with an older club, the Riverside Club. In June 1884, the club bought its first boat—a six-oared gig named the *Svea*. (Courtesy of Göran R. Buckhorn and the Malmö Rodd Klubb.)

Founded in 1909, the Swedish Colonial Society is the oldest Swedish historical group in the United States and is dedicated to preserving the legacy of the New Sweden Colony in America. On April 11, 2010, Margaret Sooy (Sally) Bridwell became its 33rd governor and the first woman to hold the governor position. (Courtesy of Margaret Bridwell.)

On November 13, 1959, Elmer Engstrom was honored in a tribute sponsored by the Swedish Colonial Society at the American Swedish Historical Society. John Wilkens is shown in the dark suit, with Sally Springer at the tea table. (Courtesy of the American Swedish Historical Museum.)

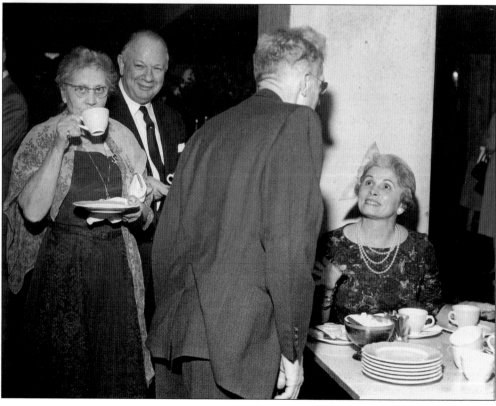

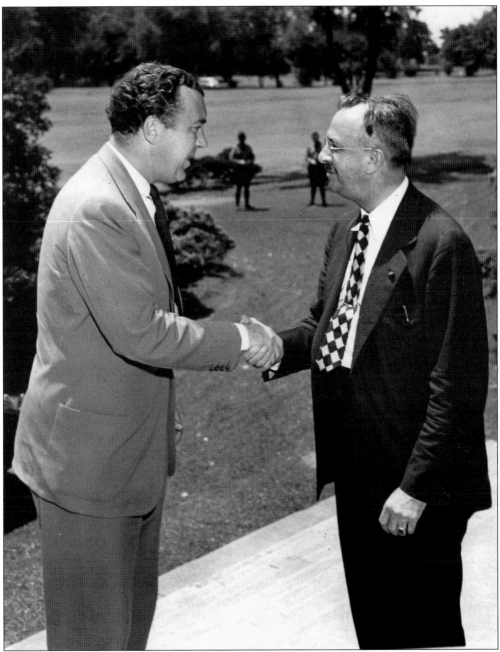

On June 29, 1945, Prince Bertil came to the United States in preparation for the celebration of the Swedish Pioneer Centennial. Here the prince (left) greets Ormond Rambo Jr., who was president of the American Swedish Historical Museum at the time. The Swedish Pioneer Centennial referred only to the later wave of immigrants and was celebrated in 1948 after several years of delay caused by World War II. (Courtesy of the American Swedish Historical Museum.)

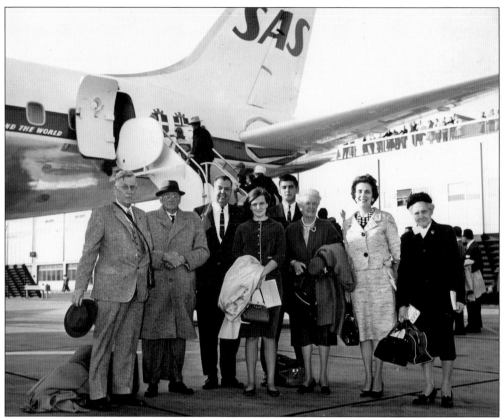

A group of Swedish Colonial Society members left Philadelphia for Stockholm on June 1, 1967. Pictured from left to right are Dr. Samuel Sturgis, Dr. Amandus Johnson, Allan Corson, Berthe Nelson, and S. W. D. Vall. Other members are unidentified. (Courtesy of the American Swedish Historical Museum.)

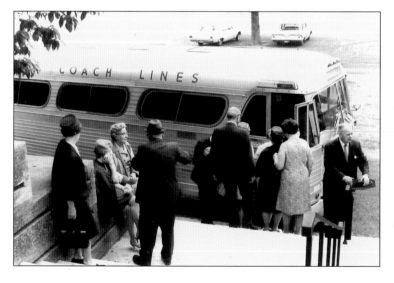

Members of the Swedish Colonial Society's Philadelphia group are shown here on June 3, 1955. In this photograph, they are boarding a bus to Idlewild Airport prior to departure for Stockholm to present a copy of Dr. Amadeus Johnson's book. (Courtesy of the American Swedish Historical Museum.)

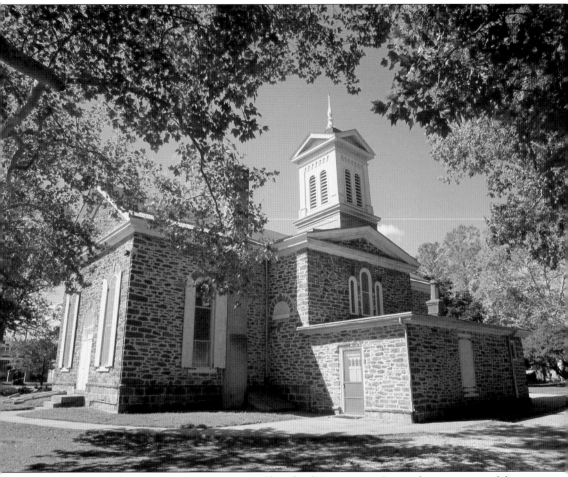

Founded by Swedish settlers in 1760, St. James Church of Kingsessing, Pennsylvania, is one of the original churches of New Sweden and is the oldest church west of the Schuylkill River. Located at 6838 Woodland Avenue, the church has been serving its community for more than 240 years. (Author's collection; photograph by Klaus Krippendorff.)

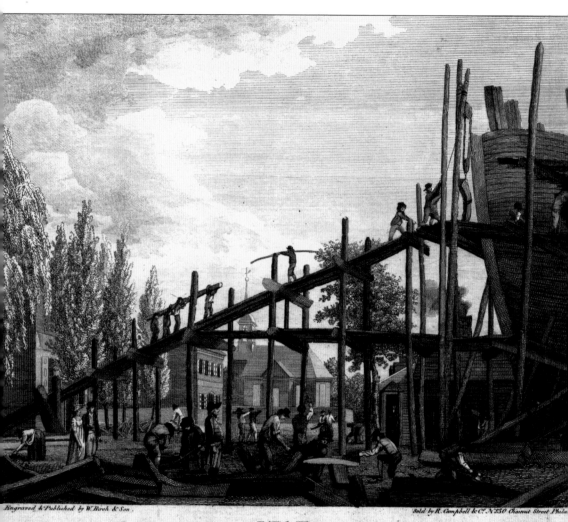

Preparation for **WAR** to defend Commerce.

The Swedish Church Southwark with the building of the FRIGATE PHILADELPHIA.

The urban Gloria Dei church in Philadelphia is shown in the background as workers build the frigate *Philadelphia* in preparation for war. The church was designated as a National Historical Site in 1942, six years before Independence Hall. The church was founded in 1677 and built between 1697 and 1700. It is considered the oldest church in Pennsylvania and the second oldest Swedish church in the United States, after Holy Trinity Church in Wilmington. (Courtesy of the Print and Picture Department, Free Library of Philadelphia.)

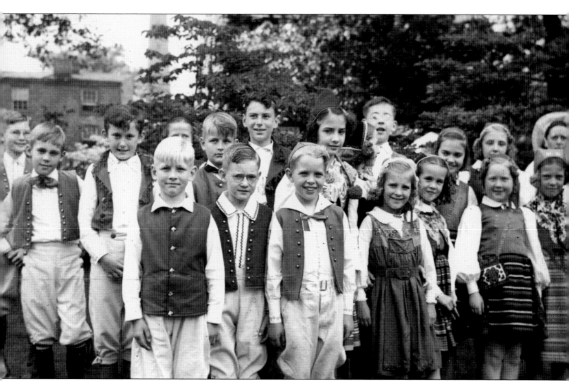

Gloria Dei Church was for many years the center of Swedish religious and social activities for the Delaware Valley, with a very active children's club. This 1940 image shows children performing at the church. (Courtesy of the Pennsylvania Historical Society.)

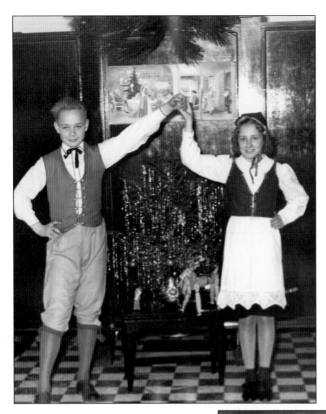

Gloria Dei is the second oldest Lutheran church in the country. Here performers from the children's club entertain members of the congregation. This picture shows a boy and girl dancing. (Courtesy of the Pennsylvania Historical Society.)

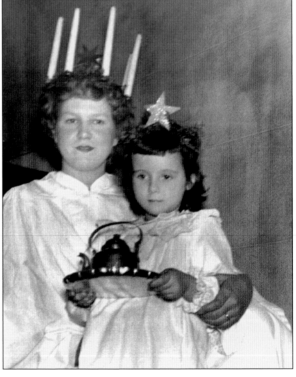

In this *c.* 1940 photograph, a child is participating in a St. Lucia festival. The festival is held on December 13 and traditionally begins the Christmas season. The event is also called the Festival of Lights. (Courtesy of the Pennsylvania Historical Society.)

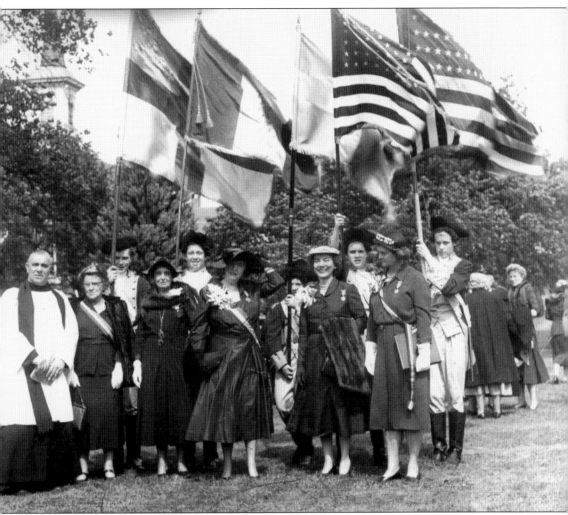

Katherine Rambo and others members of the parish are shown in this 1940s photograph on the grounds of Gloria Dei Church. The Rambo family was one of the earliest Swedish settlers and some members of the family are buried at Gloria Dei Church. (Courtesy of the Pennsylvania Historical Society.)

Swedish Colonial News

Volume 4, Number 1 Winter 2010

Preserving the legacy of the New Sweden Colony in America

Peter Stebbins Craig
1928-2009

Dr. Peter Stebbins Craig, the Swedish Colonial Society's world-renowned historian and genealogist who specialized in 17th century Swedish and Finnish immigrants to the Delaware River Valley, died Thanksgiving Day, November 28, 2009 following a brief illness. Peter passed away peacefully surrounded by family. Memorial services were held at Gloria Dei (Old Swedes') Church in Philadelphia and at the Friends Meeting in Washington, DC, where he was a member.

Dr. Craig's death came just four weeks after the Swedish Colonial Society recognized him with its Lifetime Achievement Award for his work researching the colonial experience of the settlers and their descendants into the late 18th century. He wrote over 100 articles and books on these settlers.

Dr. Craig first attracted attention among genealogists for his breakthrough article, "The Yocums of Aronameck," published in 1983. He was urged to expand his focus and look at all the New Sweden families. His book, *The 1693 Census of the Swedes on the Delaware* (1993), is the definitive work presenting family histories of 195 households then belonging to the Swedish Lutheran churches on the Delaware. His subsequent book, *The 1671 Census of the Delaware* (1999), identifies and discusses each of the residents on both sides of the Delaware River in the first English census of the Delaware. A majority of the residents were still Swedes and Finns. Dr. Craig's eight-part

continued on page 2

Swedish Colonial Society's Centennial Jubilee
Philadelphia – October 23-25, 2009

Months and months of planning became realities the weekend of October 23-25, 2009. The Swedish Colonial Society convened at Philadelphia's Radisson Warwick Hotel for the opening events of this long-awaited Centennial Jubilee Friday, October 23rd.

SCS Governor Herbert R. Rambo gratefully acknowledged the many who were involved in creating such a successful weekend of events. To name but a few, Senior Deputy

Governor Sally Bridwell was the Jubilee Registrar, sending out invitations, keeping all the records, and generally being ahead of things that needed doing. Sally also coordinated the three-city tour of the Society's exhibit *Colony to Community: The Story of New Sweden.*

Sandra Pfaff managed all sorts of arrangements, particularly chairing the Wallenberg selection committee and coordinating the event with the American Swedish Historical

continued on page 8

The *Swedish Colonial News* is the official publication of the Swedish Colonial Society. The society is open to anyone with an interest in Swedish culture and traditions. The newsletter was started in 1990 as an eight-page publication. It is currently about 20 pages and is read by many Swedish Americans all over the country. (Courtesy of the Swedish Colonial Society.)

Summer was always a wonderful time for people to enjoy the beautiful grounds of the American Swedish Historical Museum. Shown here are members of the society enjoying a Swedish summer day in Philadelphia. (Courtesy of the American Swedish Historical Museum.)

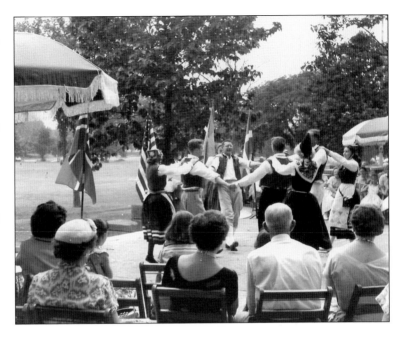

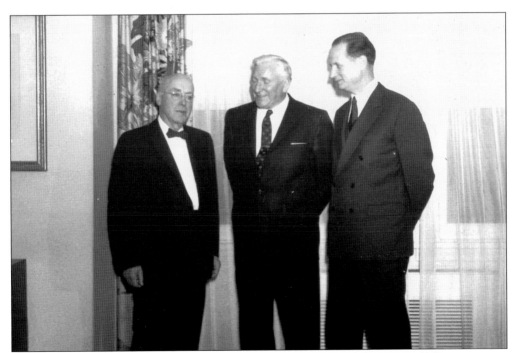

This photograph taken on December 5, 1959, at the American Swedish Historical Museum was on the occasion of Dr. Walter G. Nord (left) receiving Commandership of the Vasa Order of America. Standing with Dr. Nord are Sweden ambassador Gunnar Jarring (right) and an unidentified man. The Vasa Order of America is a Swedish American fraternal organization with lodges in America, Canada, and Sweden. (Courtesy of the American Swedish Historical Museum.)

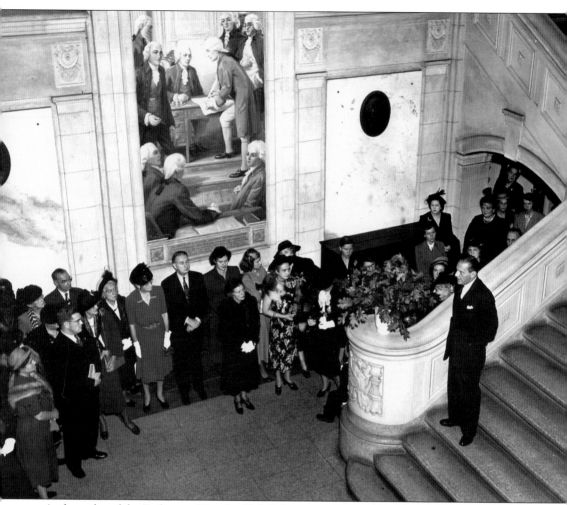

Ambassador of the Embassy of Sweden Erik Boheman is pictured standing on the grand stairway of the American Swedish Historical Museum on October 24, 1948. Ambassador Boheman wrote about the importance of cultural ties between the United States and Sweden in the postwar years. (Courtesy of the American Swedish Historical Museum.)

Five

THE EARLY BEGINNINGS

Sweden, once a great power, sent settlers to the New World to establish an economic foothold. Queen Regent Christina, the child queen of Sweden, was only 12 years old at the time the settlers left Gothenburg. The ship carrying the Swedish and Finnish settlers sailed into Delaware Bay in March 1638, naming the spot where they landed Fort Christina after their queen.

The Swedish settlement was governed successfully for several years by Johan Printz (1643–1653). He expanded the settlement north and south along the Delaware River, into present-day Maryland, and across the Delaware River into what is now New Jersey. He was a huge man, weighing, according to some accounts, more than 400 pounds. He strengthened both the colony's military and commercial enterprises and worked closely with the indigenous Americans. He was autocratic and demanding, however, and many settlers left the colony, moving as far south as Kent Island, Maryland.

Eventually the expansion of the Swedish settlers came to an end when the new governor of New Amsterdam, Peter Stuyvesant, arrived in New Sweden. He was furious that Printz's successor, Johan Rising, had decided to seize Fort Casimir, which was part of the Dutch colony (now New Castle, Delaware). He decided that the time had come to reclaim the land that the Swedes had taken from the Dutch. The fort surrendered without a fight, causing Stuyvesant to wreak havoc shortly thereafter on the Swedish settlement. With a large number of troops and ships, he took over the Delaware River, which forced the outnumbered Swedes to subsequently surrender Fort Christina.

Although Swedish sovereignty in the New World came to an end roughly 17 years after the Swedes arrived, their influence is seen today in many monuments to New Sweden and the contributions of the many Swedish Americans who helped shape the new nation.

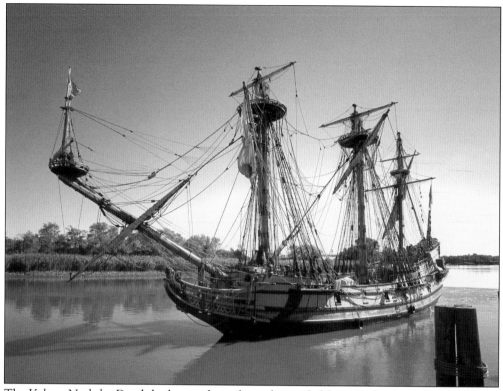

The *Kalmar Nyckel*, a Dutch-built armed merchant ship, sailed from Gothenburg, Sweden, to the New World in 1638. It arrived carrying 24 settlers of Swedish, Finnish, German, and Dutch descent, and the first settlers arrived in the Delaware Valley on March 29, 1638. The *Kalmar Nyckel*, named after the city of Kalmar in southern Sweden, made four additional voyages bringing settlers to the New World. (Courtesy of the Kalmar Nyckel Foundation; photograph by Andrew Hanna.)

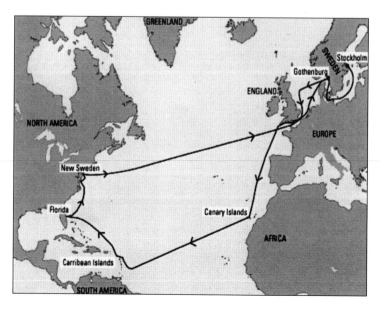

This is the route that the Swedish expedition was said to have taken from Gothenburg, Sweden. They went to the Canary Islands, through the Caribbean, over to Florida, and then up the Delaware River to Wilmington. (Courtesy of Ancestry.com.)

Here is an image of Crown Prince Gustaf Adolf dedicating a replica of the Wicaco blockhouse, which at the time was located in League Island Park (now called FDR Park) in South Philadelphia. Beside him are Philadelphia mayor W. Freeland Kendrick (center) and Secretary of State Frank B. Kellogg (right). (Courtesy of the American Swedish History Museum.)

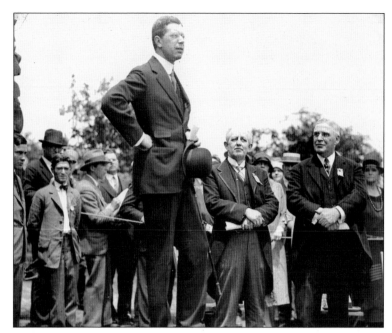

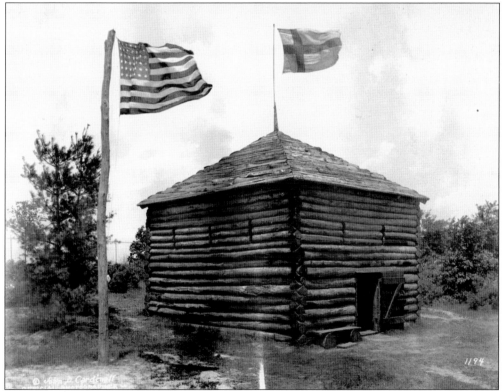

This reproduction of the Wicaco blockhouse was erected for the Sesqui-Centennial International Exposition by the Swedish Colonial Society of Philadelphia at South Broad Street and Packer Avenue. The original building was constructed in 1669 and demolished in 1698 to make room for Old Swedes Church. (Courtesy of *Philly*History.org, a project of the Philadelphia Department of Records.)

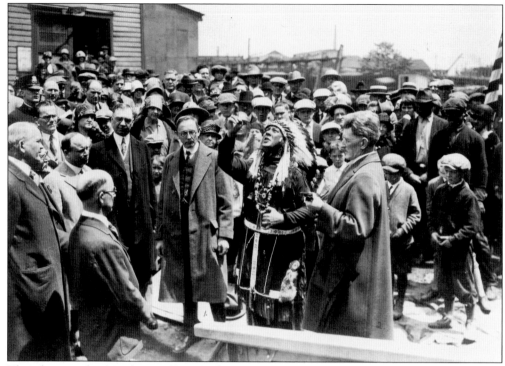

This photograph of Axel Upprall, to the left of an unidentified leader of a Delaware Valley tribe, and Amandus Johnson, to the right, was taken around 1930 at the mouth of the Delaware. The site, called the Falls, was the area where the first Swedes left the *Kalmar Nyckel* and came onto land to establish the first colony in this area. (Courtesy of the American Swedish Historical Society.)

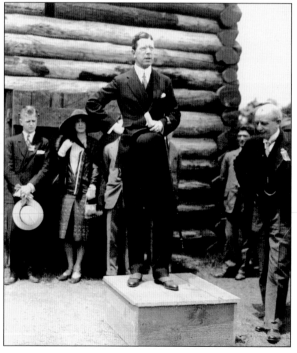

Before William Penn founded Philadelphia, the Swedes settled into a place the local Lenni Lenape tribe called Wicaco or Weccacoe (meaning "pleasant place"). For many years after the arrival of the Swedes and Finns, the area was mostly forest, with only small farms encroaching on the wilderness. When William Penn arrived and set up his city, he decided to change the name of Wicaco to Southwark, after a similarly situated neighborhood on the south bank of the Thames in London. However, the area maintained its Scandinavian roots for some time after. In fact, in the 1970s the area was renamed Queen Village in honor of Queen Christina of Sweden. On June 2, 1926, Crown Prince Gustaf Adolf dedicated a replica of the Wicaco blockhouse building. (Courtesy of the American Swedish History Museum.)

This monument, the focal point in Fort Christina State Park in Wilmington, Delaware, is a symbol of the friendship between Sweden and the United States. Executed in Swedish black granite, it was designed and built by Carl Milles, a world-famous Swedish sculptor. The monument was paid for by popular subscription in Sweden, and the number of subscribers topped 200,000. The sculpture stands 25 feet high and is surmounted by a representation of a wave bearing the *Kalmar Nyckel*. (Courtesy of the Delaware Division of Historical and Cultural Affairs.)

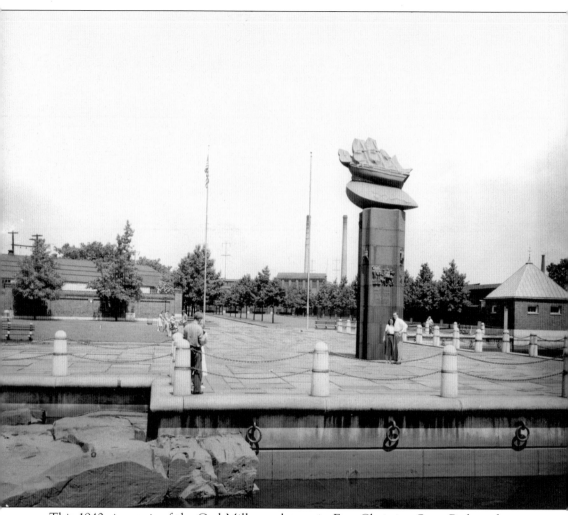

This 1940s image is of the Carl Milles sculpture in Fort Christina State Park at the water where the *Kalmar Nyckel* first sailed into Wilmington harbor. (Courtesy of the Delaware Historical Museum.)

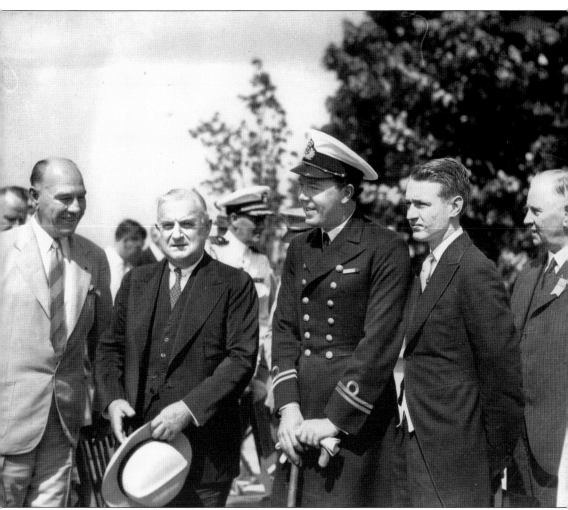

The site of the Printzhof (Governor Printz's home) and a portion of the surrounding settlement have fortunately been spared from the intensive modern development on the banks of the Delaware River. It is preserved in the 7 acres of Governor Printz Park. Archeological investigation in 1937 by the Pennsylvania Historical and Museum Commission discovered the stone foundations of Printz's house and uncovered thousands of artifacts of Swedish origin. The foundations of the Printzhof are the only visible remains of the settlement. The present park was created through the donation of land by the Swedish Colonial Society to celebrate the 300th anniversary of the founding of New Sweden in 1938. Crown Prince Bertil of Sweden dedicated the site on June 16, 1938. He is shown here with then-mayor of Philadelphia Samuel Davis Wilson (second from the left) and unidentified members of the American Swedish Historical Museum. (Courtesy of the American Swedish History Museum.)

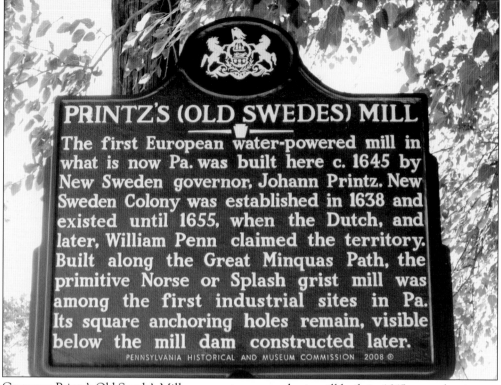

PRINTZ'S (OLD SWEDES) MILL

The first European water-powered mill in what is now Pa. was built here c. 1645 by New Sweden governor, Johann Printz. New Sweden Colony was established in 1638 and existed until 1655, when the Dutch, and later, William Penn claimed the territory. Built along the Great Minquas Path, the primitive Norse or Splash grist mill was among the first industrial sites in Pa. Its square anchoring holes remain, visible below the mill dam constructed later.

PENNSYLVANIA HISTORICAL AND MUSEUM COMMISSION 2008 ©

Governor Printz's Old Swede's Mill was a water-powered gristmill built in 1645 near what is now Upper Darby, Pennsylvania. The mill existed until 1655, when the Dutch took over the territory. The mill was built on the Great Minquas Path. This marker is on the spot of the old mill. (Author's collection; photograph by Klaus Krippendorff.)

This 1930s photograph shows the falls at Woodland Avenue, Upper Darby, which powered Old Swede's Mill. The mill itself, which was originated by Governor Printz, can be seen on the right. This primitive Norse or splash mill was one of the first industrial sites in Pennsylvania. (Courtesy of the Pennsylvania Historical Society.)

This 1894 photograph taken at the Tacony Iron Works shows the statue of a Swedish pioneer woman who now perches atop Philadelphia City Hall, right below William Penn. This bronze statue is 24 feet high, weighs 25,000 pounds, and faces the southeast toward the old Swedish site of Wicaco. The woman wears typical Swedish peasant garb and maintains a maternal image. (Courtesy of *Philly*History. org, a project of the Philadelphia Department of Records.)

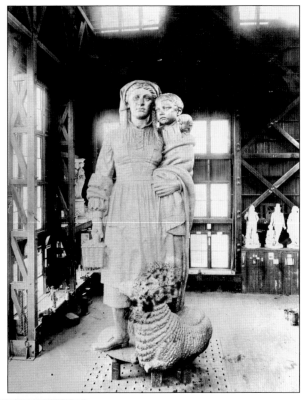

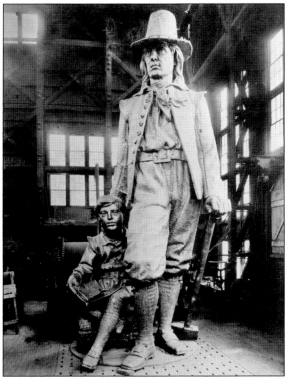

On the opposite corner of Philadelphia City Hall from the statue of a Swedish woman, a male figure is dressed like an English pilgrim but is said to represent a Swedish settler. Both statues were installed from 1894 to 1896 above the clock level of the tower and were designed by Alexander Milne Calder (1846–1923). Calder, the first of three generations of Calders who created Philadelphia sculptures, immigrated to the United States from Scotland in 1869. Calder spent many years creating some of the 250 sculptures for Philadelphia City Hall, including the two Swedish figures depicted here. (Courtesy of *Philly*History.org, a project of the Philadelphia Department of Records.)

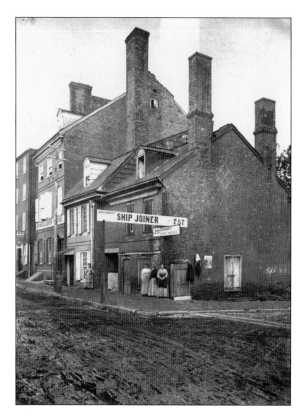

Swanson Street was in the heart of New Sweden, called Wicaco, in what is now Queen Village. This 1850s photograph shows the corner of 757 Swanson Street, which was still a Swedish neighborhood at the time. (Courtesy of the Print and Picture Collection, Print and Photograph Department, Free Library of Philadelphia.)

These street signs are located in Queen Village in Southwest Philadelphia and show how even now Sweden is represented in the Delaware Valley. Queen Street was named for Queen Christina of Sweden, and Swanson Street for a family of early settlers. (Author's collection; photograph by Klaus Krippendorff.)

Vestiges of Sweden's heritage can
still be seen today. This view of
the 700 block of Swanson Street
is how it looks today as opposed to
how it looked in the photograph
on page 84. (Author's collection;
photograph by Klaus Krippendorff.)

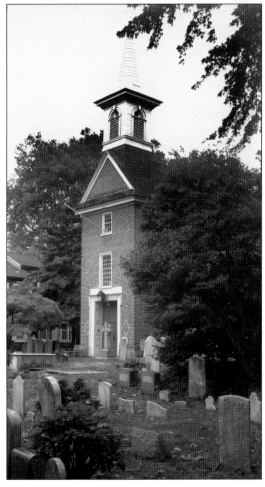

At right, Gloria Dei Church at 916 South
Swanson Street is the second oldest
Swedish church in the United States.
Pastor Andreas Rudman dedicated its
second building on July 2, 1700. On
May 27, 1861, local residents formed the
Union Volunteer Refreshment Saloon
and Hospital at Swanson Street and
Washington Avenue. Swanson Street
was named for the Svenssoner family
of three brothers—Olof, Anders, and
Sven—who anglicized their name
to Swanson. (Author's collection;
photograph by Klaus Krippendorff.)

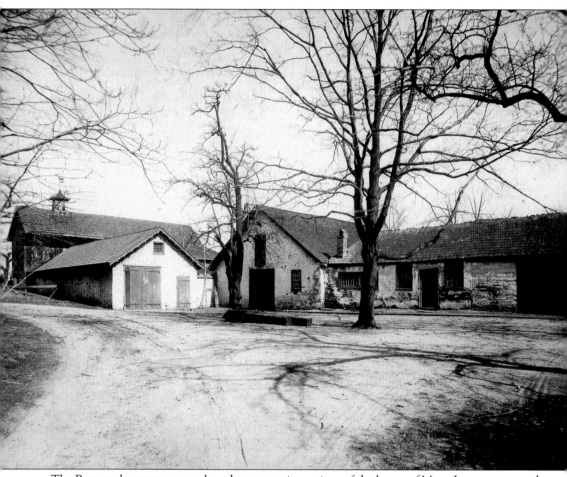

The Bartram house was once thought to contain sections of the house of Mans Jonasson, an early Swedish colonist. However, recently historians have determined that the Bartram house does not contain any Swedish artifacts but is located on the grounds of an early plantation called Aronameck. This 1895 photograph by William H. Rau shows, from left to right, the barn, stable, coach house, and seed house. (Courtesy of the Mira L. Dock Collection, the John Bartram Association.)

Bartram's Garden, located at Fifty-fourth Street and Lindberg Boulevard in Philadelphia, is the oldest botanical garden in the United States. It stands on an original Swedish Colonial plantation known as Aronameck. Mans Jonasson lived on the Aronameck plantation, believed to be more than 100 acres. Unfortunately, the heirs to whom he ceded his land went into debt, and the land was sold at sheriff's sale to a Quaker named John Bartram in September 1728. Bartram later won worldwide acclaim for his botanical home. His home, including the core structure built by Mans Jonasson, is shown on this map of Bartram's Garden, originally drawn in 1758. (Courtesy of the John Bartram Association.)

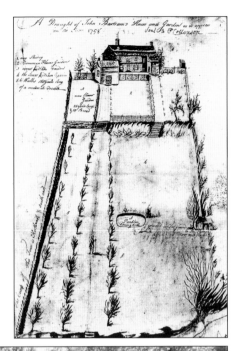

These Winter Rambo apple trees, on the grounds of Bartram's Garden, were introduced to the American colony of New Sweden in 1637 by Peter Gunnarsson Rambo, a Swedish immigrant. Rambo probably brought apple seeds and seedlings with him from Sweden. The greenish-yellow apple with red stripes ripens in mid-summer and is good for pies, jelly, and drying. The name Rambo is derived from Peter Gunnarsson's Swedish home on Rmberget (originally Ramnberget, meaning "Raven Mountain") in what today is part of Gothenburg. (Author's collection; photograph by Klaus Krippendorff.)

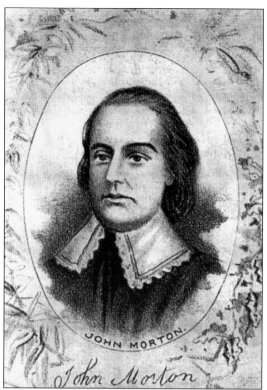

This *c.* 1876 formal portrait of John Morton (1724–1777) by engraver Ole Erekson depicts the Swedish American signer of the Declaration of Independence. John Morton was born in Ridley, Pennsylvania, in 1724 and served in the Continental Congress (1774–1777). (Courtesy of the Library of Congress.)

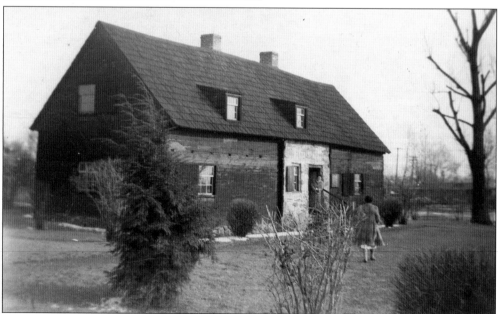

The Pennsylvania birthplace of John Morton dates from 1698. Morton was active in Pennsylvania politics most of his adult life after being elected to the Pennsylvania Provincial Assembly in 1756. He was elected to the First and Second Continental Congress and sided with Benjamin Franklin, who was in favor of declaring independence. John Morton was the first signer of the Declaration of Independence to die. (Courtesy of the Pennsylvania Historical Society.)

A sign outside the house reads "Boelsen Cottage 1684." In this picture, an unidentified woman sits outside the two-room house, which is believed to have been surveyed by Thomas Home in 1684. A kitchen was added in 1696. (Courtesy of the Fairmount Park Historic Resource Archive; photograph by James Cramer.)

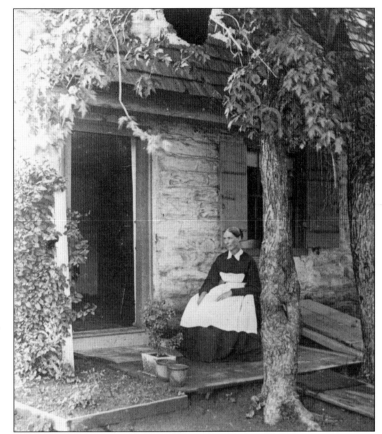

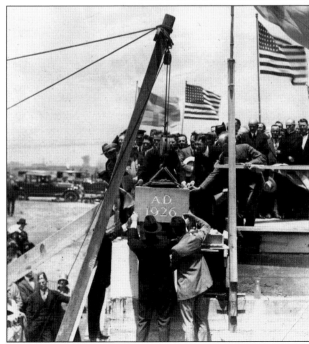

Swedish Day on June 6, 1926, was one of the first days to celebrate a foreign country at the Sesqui-Centennial International Exposition. Here Crown Prince Gustaf Adolf lays the cornerstone for the new American Swedish Historical Museum, which was going to be called the John Hanson–John Morton Memorial Building. The building was almost finished by October 1927, but the Depression and other funding issues prevented the completion until the mid-1930s. (Courtesy of the American Swedish Historical Museum.)

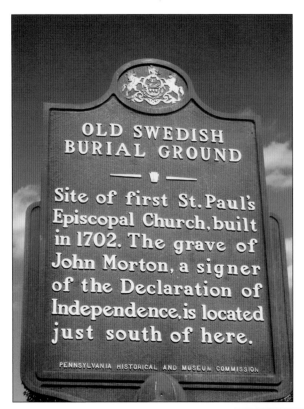

A historical marker indicates the location of the grave of John Morton at St. Paul's Burying Ground, once known as Old Swedish Burial Ground. Swedes from the colonial period are buried in the graveyard, which is located at Welch and East Third Streets in Chester, Pennsylvania, in Delaware County. (Author's collection; photograph by Klaus Krippendorff.)

The monument to John Morton, located in the Old Swedish Burial Ground, is a tall marble pillar with inscriptions on all sides about the Scandinavian signer of the Declaration of Independence. On the east side of the column, a statement indicates that there was a tie vote within the Pennsylvania delegation. Two members voted in the affirmative; two voted in the negative. The tie continued until the vote of the last member, John Morton, who decided the vote of the State of Pennsylvania with regard to independence. (Author's collection; photograph by Klaus Krippendorff.)

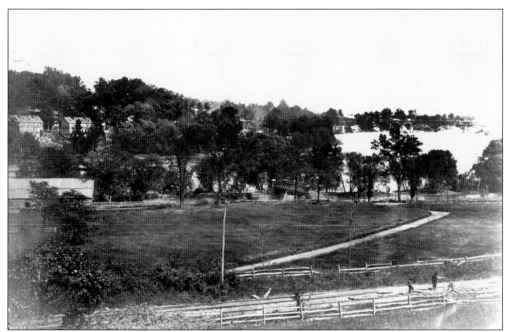

Eventually Swedish settlers moved further north into the Philadelphia region, settling in what is now Fairmount Park. This 400-acre tract of land, shown in this 1870s photograph, was purchased by two early settlers, one of whom was probably Swedish. They farmed the land facing the Schuylkill River. (Courtesy of the Fairmount Park Historic Resource Archive; photograph by James Cramer.)

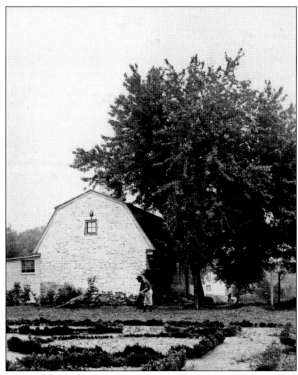

This 1870 image shows a man tilling the field beside the Boelsen Cottage. With its gabled roof, the cottage is a prime example of Swedish architecture. This part of Philadelphia along the river was settled by the Swedes after they were pushed out of the center of the city upon the arrival of William Penn. (Courtesy of the Fairmount Park Historic Resource Archive; photograph by James Cramer.)

GARBO

As Queen Christina

Two "stills" from the new Metro-Goldwyn-Mayer motion picture show the most publicized face of modern times. The film, shortly to be released, is under Rouben Mamoulian's direction. John Gilbert plays opposite Garbo.

In 1932, Swedish actress Greta Garbo gave a moving performance in the role of the queen of Sweden in the Metro-Goldwyn-Mayer movie *Queen Christina*. Directed by Rouben Mamoulian, the film is considered one of Garbo's best, although it is debatable how authentic the film is in terms of Queen Christina's life. (Courtesy of the Print and Picture Collection, Print and Photograph Department, Free Library of Philadelphia.)

Greta Louisa Gustaffson (1905–1990) is pictured on the day of her first communion in 1925. She was born in Stockholm, the youngest of three children. Her father was an unskilled worker, and she lived in a house without electricity or water. This young Swedish woman would go on to an illustrious career in movies as Greta Garbo. (Courtesy of the Print and Picture Collection, Print and Photograph Department, Free Library of Philadelphia.)

Six

MONUMENTS, ART, AND PERSONALITIES

One feature of Swedish arts in Sweden, and to some extent in the Delaware Valley, was the formation of art associations. Members of these associations, whether artists or patrons, bought and sold art collectively. Many of the works of Sweden's great artists, such as Anders Zorn, Carl Milles, and Carl Larsson, can be seen in the Delaware Valley as a result of these associations.

Even people who have not seen the work of some of Sweden's famous fine artists will have been exposed to the Swedish design sensibility through products designed for the home. Swedish architecture and design are very practical, a feature that owes its development to the Functionalist movement, dating to the Stockholm Exhibition of 1930. The influence of the Functionalist movement can still be seen in the products of IKEA, many of which are based on the design ethos of Karin Bergöö Larsson, wife of Sweden's most famous painter. Swedish artistry is also seen in glassware from makers such as Kosta Boda and Orrefors, prominent designers of fine stemware and crystal vases. Many examples of Swedish architecture can still be seen in the Delaware Valley today, not only in the form of Swedish cabins, but also in elaborate sculptures and modest cottages that exhibit the functional design of Swedish dwellings. Swedish monuments dot the Delaware Valley and can be seen in public areas and municipal buildings and on college and university campuses.

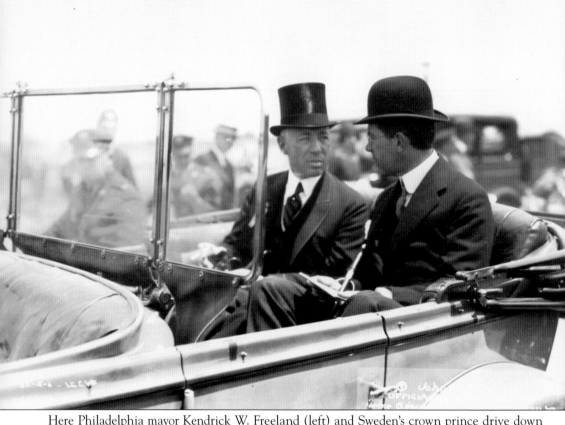

Here Philadelphia mayor Kendrick W. Freeland (left) and Sweden's crown prince drive down Broad Street in a motorcade on June 2, 1926, during the Sesqui-Centennial International Exposition. The exposition was somewhat disappointing, as it did not have as much international participation as previous world's fairs did. The Swedish delegation, however, did have a major part in the festivities, with a number of Swedish dignitaries attending the event, including the crown prince; his wife, Crown Princess Louise; and the prince's son, Prince Bertil. (Courtesy of *Philly*History.org, a project of the Philadelphia Department of Records.)

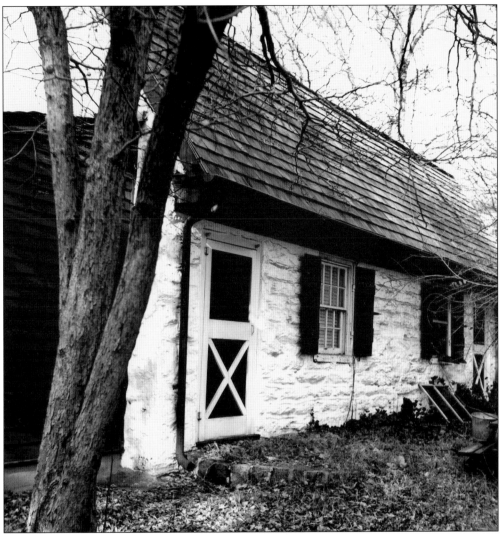

Although the claim is difficult to authenticate, Boelsen Cottage is considered by some to be the second-oldest house in the Commonwealth of Pennsylvania. Part of the Belmont estate, the cottage sits within the confines of West Fairmount Park. The vernacular architecture reflects early Dutch and Swedish styles, with a gambrel roof, small casement windows, and a corner fireplace. The original owners of the cottage were John Boelsen, possibly an early Swedish settler, and Jan Schoeten (also know as Skutton), a Dutch seaman. (Courtesy of the Fairmount Park Historic Resource Archive; photograph by James Cramer.)

Anders Zorn (1860–1920) is the only non-American painter to create an official presidential portrait (of William Taft in 1911). He also painted famous, unofficial portraits of Grover Cleveland and Theodore Roosevelt. His etchings can be viewed at the American Swedish Historical Museum's balcony level. The small collection focuses on another Zorn specialty: the female form in a naturalistic Swedish setting. This is a self-portrait from 1896. (Courtesy of the Library of Congress.)

Philadelphia is a great place to see Swedish art. Claes Oldenburg, born in Stockholm in 1929, is known for his public art. His famous sculpture *Clothespin* (1976), located across from city hall, is 45 feet high and dominates the area. According to some art critics, it is read as a visual pun referencing the tower of city hall. (Author's collection; photograph by Klaus Krippendorff.)

Another of Oldenburg's famous works, *Split Button* is located in front of the Van Pelt Library at the University of Pennsylvania. The sculpture was erected in 1976. Oldenburg has been quoted as saying the "split" represents the Schuylkill River. It divides the button into four parts for William Penn's original Philadelphia squares. (Author's collection; photograph by Klaus Krippendorff.)

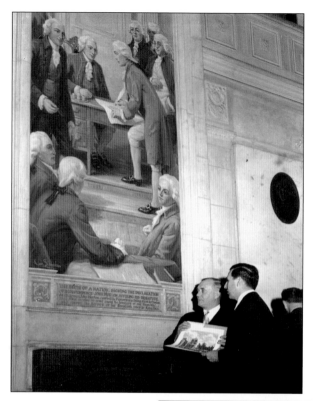

The painting to the left of the grand staircase at the American Swedish Historical Museum was painted by Christian von Schneidau (1893–1976). This painting depicts John Morton, a Swedish American signer of the Declaration of Independence. The painter was born in Sweden of noble birth and immigrated to the United States in 1906. (Courtesy of the American Swedish Historical Museum.)

Elizabeth Z. Swenson, pictured around 1941, holds a purchase deed dating to the year 1288 at the American Swedish Historical Museum in Philadelphia, where the deed is still on display. The deed issued to Bishop Peter of Västerås, Sweden, gave him a one-eighth share in a copper mine in exchange for certain lands and properties. The document is written in Latin and has several pendant seals of certification, or signatures, attached. (Courtesy of Paley Library Archives, Temple University.)

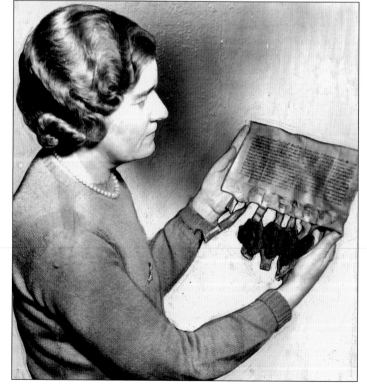

Tiffany and Company, the New York jeweler, set an elegant breakfast table with blue and white Swedish stoneware for this 1970 image by Bill Cunningham. Swedish china, and particularly Swedish glassware, is very famous. (Courtesy of the Paley Library Archives, Temple University.)

The *Nordstjernan* (North Star) was the oldest Swedish-language newspaper in North America. The Swedish Printing Association (Svenska Tryckföreningen) first began publication of the newspaper on September 21, 1872. The edition shown here was published on November 2, 1972. Published in Swedish, the newspaper ran articles of interest to Scandinavians, such as news items from Sweden, cartoons, and advertisements for Swedish products, book reviews, and other topics of interest. (Courtesy of the American Swedish Historical Museum.)

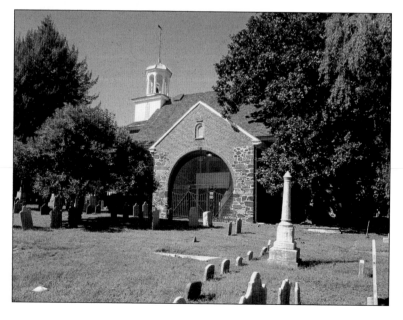

This view of Holy Trinity (Old Swedes Church), in Wilmington, built in 1698, shows the church and the graveyard. The pastor of the church, Eric Björk, was responsible for building the present stone church at the site of the old burial ground of Fort Christina. (Author's collection; photograph by Klaus Krippendorff.)

This marker is on the site of St. James Church on Woodland Avenue, once called Kings Highway, in an area of Philadelphia called Kingsessing. The marker designates the cornerstone of the church, which was laid on August 6, 1762. The building was completed the next year. It was 60 feet long and 45 feet broad, with a gallery inside. The building had a Swedish tile stove for heat. (Author's collection; photograph by Klaus Krippendorff.)

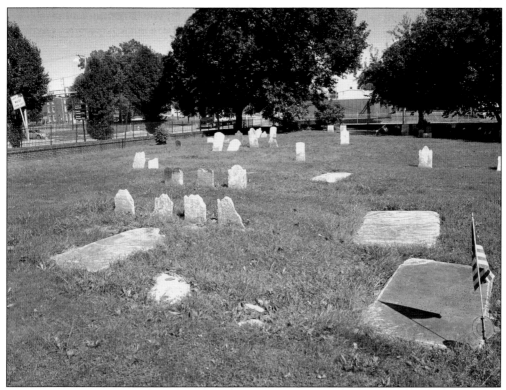

The old Swedish gravesite contains the remains of many Swedes from the early Swedish Colony in what is now Delaware. There are more than 5,000 gravestones in the graveyard. (Author's collection; photograph by Klaus Krippendorff.)

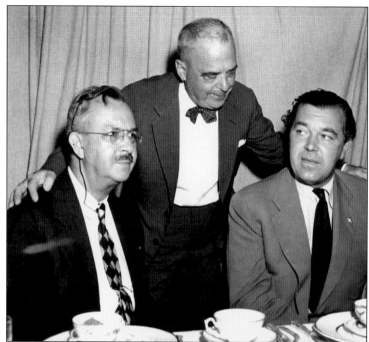

Pictured from left to right, Ormond Rambo Jr. (president of the American Swedish Historical Museum), an unidentified man, and Prince Bertil are seen at a luncheon at the museum prior to the Swedish Pioneer Centennial celebration on June 29, 1945. (Courtesy of the American Swedish Historical Museum.)

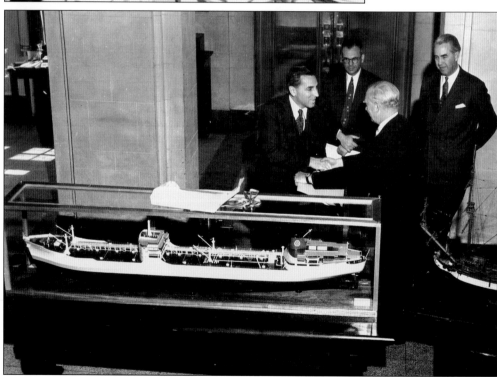

In meeting to prepare for a special exhibit on March 27, 1955, members of the American Swedish Historical Museum stand in front of a replica of the original USS *Monitor*. Standing from left to right are Walter Phillips, A. J. Orenstein, Gustav Thordin, and Count Karl Douglass. (Courtesy of the American Swedish Historical Museum.)

Seven

SWEDISH CULTURE

Swedish and Swedish American culture contributed to enhancing the significance of the Delaware Valley, from patriots, to signers of the Declaration of Independence, to artists, entrepreneurs, Swedish royalty, and everyday citizens. Many of these people lived in and around the Delaware Valley, but others, like Jenny Lind, Fredrika Bremer, and Charles Lindberg, only passed through on their journeys to other places. The Swedish royals, too, traveled to the area only to participate in celebrations commemorating the Swedish colonial period. But they honored the achievements of Swedes of that early colonial period, such as Pastor Erik Björk and his wife, Christina Stalcop, along with their portrait painter, Gustavus Hesselius.

Fredricka Bremer, a Swedish feminist who traveled frequently to the United States, is honored by her own special gallery at the American Swedish Historical Society. Many famous Swedish vocalists also came to the Delaware Valley to perform and P. T. Barnum, the great American showman, brought many Swedish acts to this area.

Corporations, too, have had a significant impact on the economic development of the Delaware Valley. Swedish furniture retailer IKEA has revolutionized the home decorating industry. Everyone from college students to empty nesters and almost everyone in between knows and uses IKEA products. SKF, a Swedish-run bearing company whose products help airplanes fly safely, is located in the Delaware Valley, spurring employment and productivity.

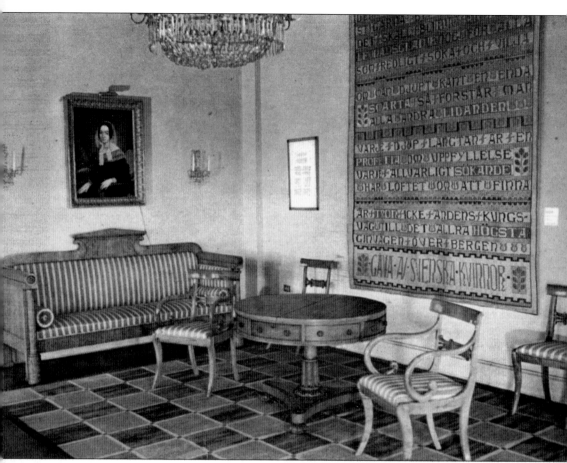

The *Philadelphia Inquirer* published this image of the Fredrika Bremer Room at the American Swedish Historical Museum on October 21, 1945. Born in 1801, Fredrika Bremer was an influential Swedish writer and feminist activist. She greatly influenced social development in Sweden, especially with regard to women's issues. She traveled to the United States between 1849 and 1851 and died in 1865. (Courtesy of the American Swedish Historical Museum.)

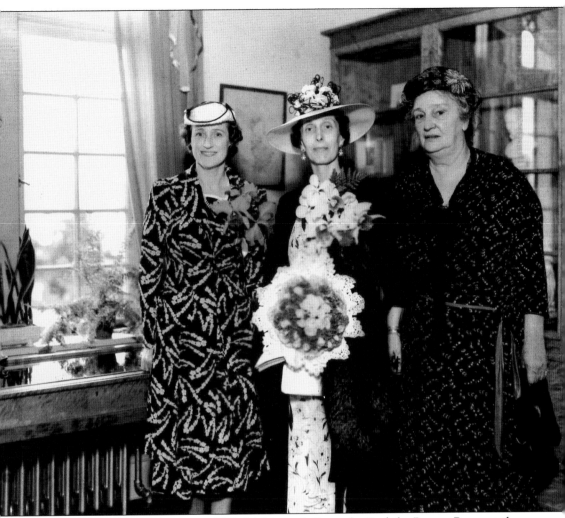

In 1938, the Swedish royals came to Philadelphia to dedicate the Fredrika Bremer Room at the American Swedish Historical Museum. Women of Sweden gifted the furnishings to the women of America in honor of the leading Swedish feminist. In attendance were, from left to right, Mrs. George Earle, Crown Princess Louise, and Mrs. James Starr, wife of the chairman of the Bremer room. (Courtesy of the American Swedish Historical Museum.)

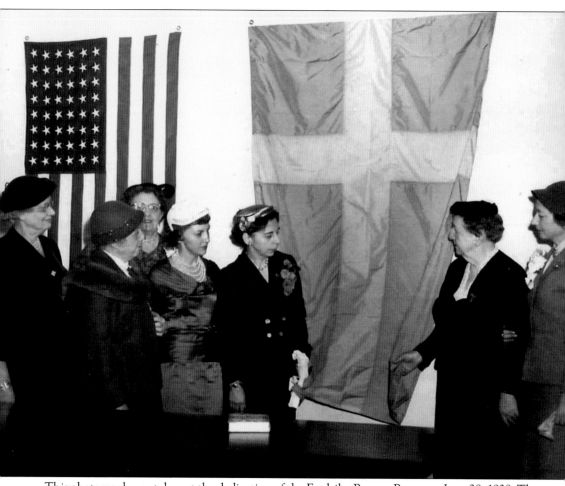

This photograph was taken at the dedication of the Fredrika Bremer Room on June 28, 1938. The women shown here were members of the committee that were committed to bringing about the dedication of this room. (Courtesy of the American Swedish Historical Museum.)

Mamie Eisenhower, wife of Pres. Dwight D. Eisenhower, accepted a lifetime membership on the Fredrika Bremer Room Committee and was made high patroness of the group in 1954. Her mother was a Carlson, a family with roots in the province of Halland, Sweden. (Courtesy of the Print and Picture Department, Free Library of Philadelphia.)

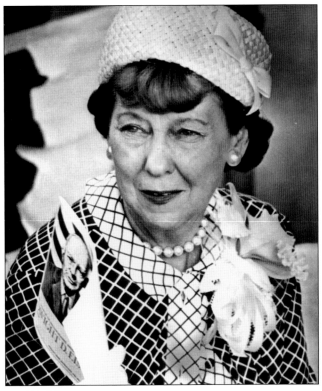

Till förmän för
Fredrika Bremer-rummet
i Philadelphia 1938
SM.EXT (1)

The statement on this celebration postcard, which shows both Fredrika Bremer and the American Swedish Historical Museum, translates to "For the benefit of the Fredrika Bremer Room, Philadelphia 1938." The back of the Fredrika Bremer Room postcard says "Merry Christmas and Happy New Year" in Swedish. (Courtesy of the American Swedish Historical Museum.)

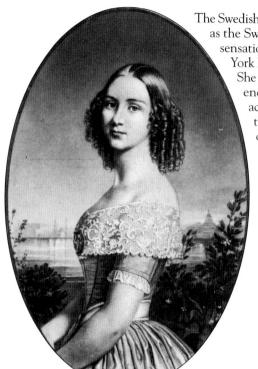

The Swedish opera singer Jenny Lind (1820–1887) was known as the Swedish Nightingale. P. T. Barnum sponsored her sensational American performances. Sailing into New York harbor, Lind was welcomed by a massive crowd. She performed in Philadelphia three times and earned enough on the tour to engage in philanthropic activities on her return to Sweden. (Courtesy of the Print and Picture Department, Free Library of Philadelphia.)

This second image of Jenny Lind, when she was older, was taken toward the end of her career. The American Swedish Historical Museum devotes an entire room to Lind, where a bust of her is on display. She was a phenomenon in the 19th century and provided many in the Delaware Valley with musical pleasure on her tour. (Courtesy of the Print and Picture Department, Free Library of Philadelphia.)

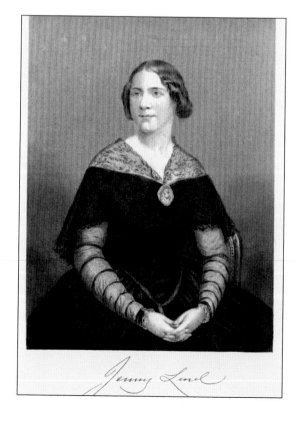

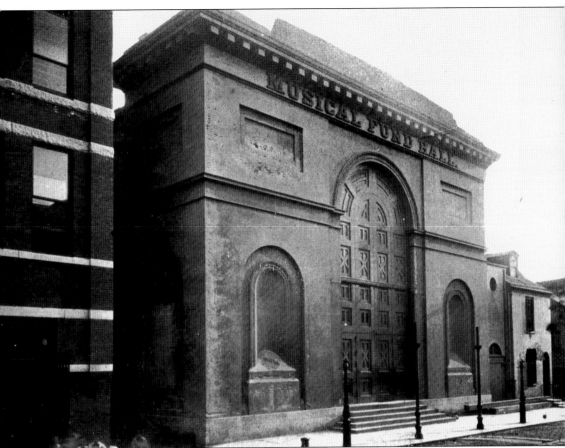

Jenny Lind performed October 18–19, 1850, at the Musical Fund Hall on Locust Street in Philadelphia, earning $19,000 for the two performances. The Musical Fund Society was founded in 1820 to formalize performances of local and international musicians and artists. (Courtesy of the Print and Picture Department, Free Library of Philadelphia.)

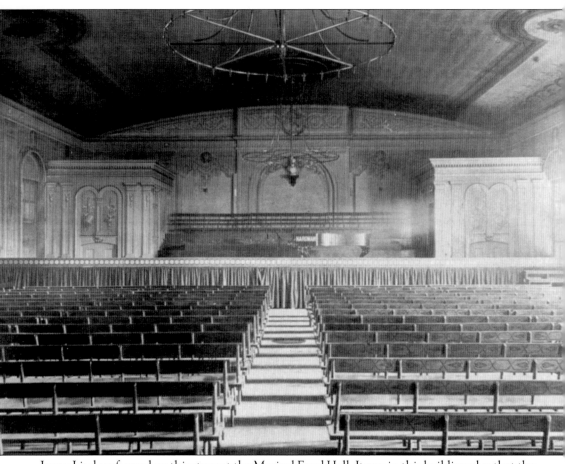

Jenny Lind performed on this stage at the Musical Fund Hall. It was in this building also that the first Republican National Convention was held on June 1856. Charles Dickens also lectured here in 1842. (Courtesy of the Print and Picture Department, Free Library of Philadelphia.)

The great American showman
P. T. Barnum (1810–1891) persuaded a
Philadelphia minister to lend him $5,000
to help finance Jenny Lind's American
tour, presumably with the belief that the
Swedish Nightingale, who gave charity
concerts at hospitals and orphanages,
would be a good influence on American
morals. (Courtesy of the Print and Picture
Department, Free Library of Philadelphia.)

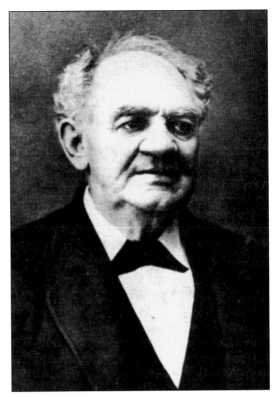

P. T. Barnum is shown with Tom
Thumb in this drawing by Fritz
Eichenberg. Barnum was so successful
as a showman that he was able to pay
Jenny Lind an unprecedented $1,000
a night for 150 nights. (Courtesy of
the Print and Picture Department,
Free Library of Philadelphia.)

Swedish American Gloria Swanson (1899–1983) was one of the great beauties of American cinema. She was born in Chicago to a Swedish American father. She came to the Delaware Valley for the Sesqui-Centennial International Exposition. (Courtesy of the Print and Picture Department, Free Library of Philadelphia.)

As a guest of Pres. Franklin D. Roosevelt on June 27, 1938, Prince Bertil led a parade in the driving rain in celebration of the 300th anniversary of the arrival of the Swedes in the Delaware Valley. His father, Crown Prince Gustaf Adolf, was to have been part of the celebration, but due to an illness, Prince Bertil took over. Prince Bertil, then 26 years old and a naval attaché on leave from Sweden's Paris legation, represented his ailing father at public functions in both Wilmington and Philadelphia. (Courtesy of the American Swedish Historical Society.)

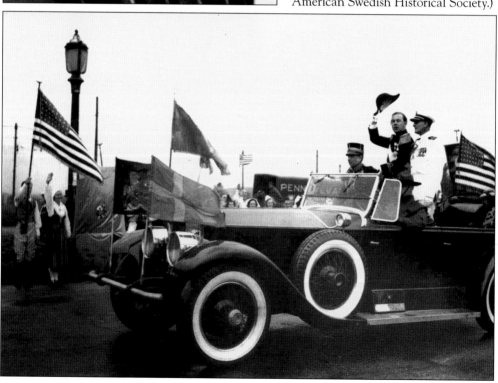

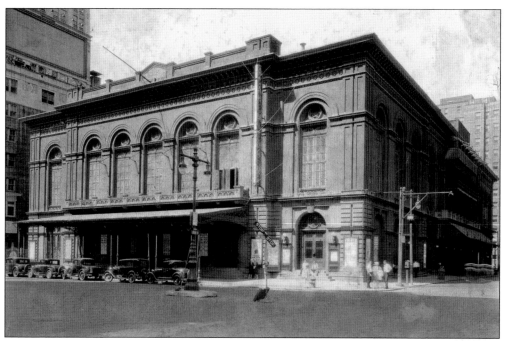

Another great Swedish soprano, Birgit Nilsson (1918–2005) came from a country farm in the Skåne area of Sweden. She was somewhat of a prodigy, playing a toy piano at an early age. She was considered the premier Wagnerian soprano and often recorded with Philadelphia's great maestro, Leopold Stokowski. This image is of Philadelphia's legendary Academy of Music, the premier opera house of the Delaware Valley, where many Swedish artists performed. (Courtesy of the Library of Congress.)

This contemporary image of Gloria Dei Church in Philadelphia illustrates the beauty of the earliest examples of American stained glass windows. These windows were placed much after the original building was constructed in 1846. The church is the second-oldest in the Delaware Valley. (Author's collection; photograph by Klaus Krippendorff.)

An unidentified young child in Swedish folk dress stands on the lawn of the American Swedish Historical Museum in the late 1940s looking a little lost. The group behind the unidentified child are May Day revelers enjoying the beautiful spring weather on the grounds of the museum. (Courtesy of the American Swedish Historical Museum.)

Sweden has maintained a consulate in the Delaware Valley for a number of years. Currently there are 32 cities in the United States with a consulate. Shown in this 1956 image are three Swedish honorary consuls. From left to right are (seated) Maurice Hogeland, former treasurer of the American Swedish Historical Foundation and Swedish consult for 40 years, and Mathias Moe, the Norwegian consult; (standing) Donald Hogeland, son of Maurice, and an unidentified man. Donald was the Danish consul for 30 years and the Swedish consul for 20 years. (Courtesy of the American Swedish Historical Museum.)

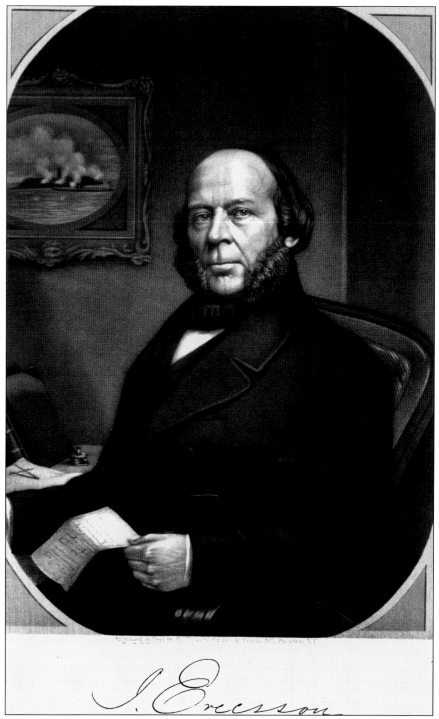

John Ericsson (1803–1889), an inventor born in Långbanshyttan, Värmland, Sweden, created the design for the USS *Monitor*, which was novel for an armored ship. The ship played a role in several Union victories against the South during the Civil War. (Courtesy of the Print and Picture Department, Free Library of Philadelphia.)

A fountain dedicated to John Ericsson sits at the west end of Eakins Oval in Philadelphia's Fairmount Park (on the Parkway at Twenty-fourth Street). Its inscription reads, "Dedicated to the memory of Captain John Ericsson, scientist, inventor, and patriot. Born in Sweden July 31, 1803. Died in America, the country of his adoption, March 8, 1889." (Author's collection; photograph by Klaus Krippendorff.)

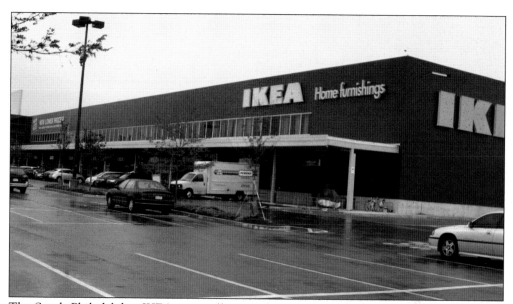

The South Philadelphia IKEA store sells everything from refrigerators and other appliances to plants, wall hangings, and linens. IKEA is one of the largest furniture and home furnishing brands in the world. Founded by Ingvar Kamprad, one of the world's most reclusive and wealthy billionaires, IKEA provides budget-friendly home goods. (Author's collection; photograph by Klaus Krippendorff.)

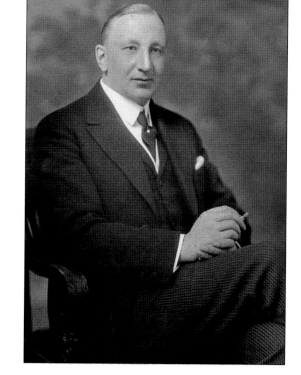

In 1938, Finnish minister Dr. A. L. Anstrom arrived in the Delaware Valley to help celebrate the first Finnish settlement that arrived in America 300 years prior. The event was held in Chester, Pennsylvania, on June 29, 1938. In 1638, Finland was a part of the Swedish empire. (Courtesy of *Philly*History.org, a project of the Philadelphia Department of Records.)

Charles Lindbergh, an American of Swedish descent, was the first to fly alone and non-stop across the Atlantic Ocean. The mechanisms of his plane, the *Spirit of St. Louis*, contained a large number of SKF bearings from the Philadelphia plant. His flight brought attention to SKF, and the company began to expand across the United States. (Courtesy of the Print and Picture Department, Free Library of Philadelphia.)

Charles Lindbergh, shown here in this 1938 photograph, pushes his plane with the help of his wife. According to The *Evening Bulletin*, when Col. Charles A. and Anne Morrow Lindbergh arrived at Le Bourget for their flight to Berlin, they found a shortage of help at the airport. (Courtesy of the Print and Picture Department, Free Library of Philadelphia.)

Even today, the Swedes are recognized in South Philadelphia. This image shows the name of a Philadelphia condominium on Christian Street at Swanson, "Court at Old Swedes," in an area near Gloria Dei Church that was once occupied by Swedish and Finnish settlers. (Author's collection; photograph by Klaus Krippendorff.)

Fred Ullberg, 18, worked on the city hall statues (see page 84) created by Alexander Milne Calder at the Tacony Iron Works installed in 1894 atop city hall. Ullberg, a Dane, was one of the many from the Wissinoming and Tacony areas who worked on construction sites and in ironwork foundries around Philadelphia. (Courtesy of the City Hall Tourist Office.)

This is a 1914 view of the bridge at League Island Park, which would be renamed FDR Park for the Sesqui-Centennial International Exposition of 1926. The famous landscape architecture firm of Olmsted Brothers designed the park, which was reclaimed mostly from marshlands. The American Swedish Historical Museum is located here. (Courtesy of *Philly*History.org, a project of the Philadelphia Department of Records.)

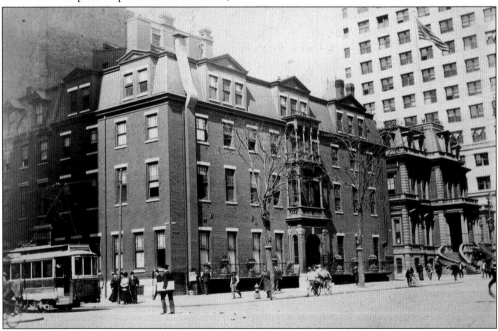

Great Swedish performers, such as Christina Nilsson (1843–1921) and Jussi Björling (1911–1960), gave many wonderful performances in Philadelphia. When they came to the Delaware Valley, they frequently stayed at the Bellevue-Stratford Hotel, located on Broad Street at Walnut Street. The Beaux-Arts hotel was built between 1902 and 1904. This 1930s image shows the hotel before the addition of many more stories. (Courtesy of the Print and Picture Department, Free Library of Philadelphia.)

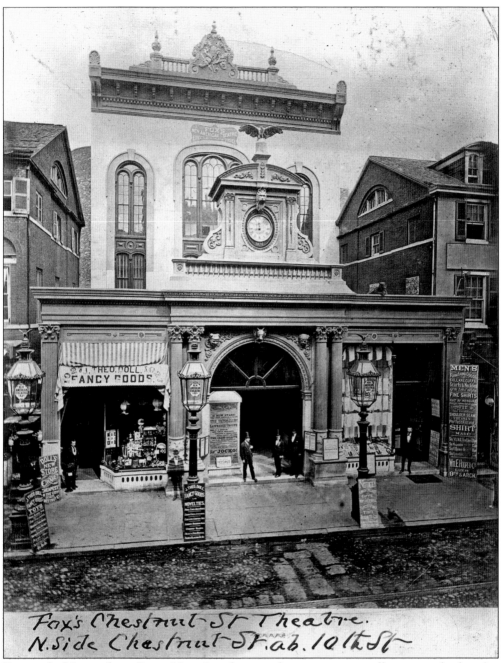

Fox's Chestnut St Theatre.
N. Side Chestnut St. ab. 10th St

During the Metropolitan Opera House's early years, the company annually presented a dozen or more opera performances in Philadelphia throughout the season on Tuesday evenings. Over the years, the number of performances was gradually reduced until the final Philadelphia season in 1961 consisted of only four operas. The last performance was on March 21, 1961, with celebrated Swedish dramatic soprano Birgit Nilsson (1918–2005). After the Tuesday night performances ended, the Met returned to Philadelphia on its spring tour in 1967, 1968, 1978, and 1979. The Chestnut Street Theatre was built in 1862 on the north side of Chestnut Street between Twelfth and Thirteenth Streets. (Courtesy of the Print and Picture Department, Free Library of Philadelphia.)

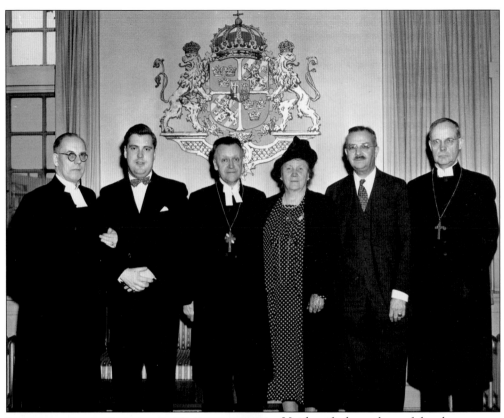

Unidentified members of the clergy meet with members of the American Swedish Historical Museum at the museum. Because the churches were so important in the early days of the colony, those ties with clergy and churches are maintained today. Many events and festivals take place through the church. Church pastors work very closely with the museum. (Courtesy of the American Swedish Historical Museum.)

Anders Rudman was one of three early missionaries sent from Sweden to the New Sweden colony in the United States. Two other prominent clerical leaders of the colony were Erik Bjork and Jonas Auren. Only Anders Rudman is buried in Gloria Dei Church in Philadelphia. Shown here is the lovely brick walkway behind the church and the graveyard. (Author's collection; photograph taken by Klaus Krippendorff.)

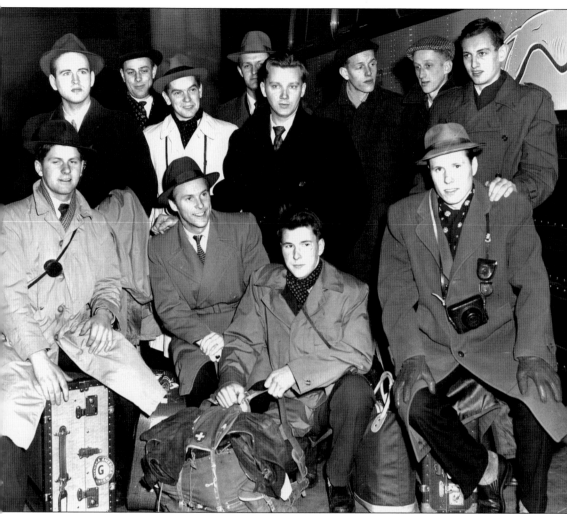

This image from the 1930s shows young men who have come from various areas in Sweden to work on farms in the United States. They arrived in Philadelphia as guests of the American Swedish Historical Museum and then went to various farms in the Delaware Valley and elsewhere to learn about agriculture and farming. (Courtesy of *Philly*History.org, a project of the Philadelphia Department of Records.)

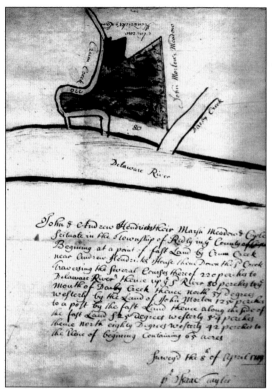

The land map of Hendrickson acreage shows the plantation in Ridley Township that bordered on the Delaware River, which is shown in the plot. This area (see page 42) is the sprawling site of many Boeing facilities in Philadelphia by the airport. (Courtesy of the Old Swedes Foundation.)

A lesser-known style of Swedish architecture, adopted by the English when they took over New Sweden in 1682, was the gambrel roof, a roof with two slopes, of which the lower slope was steeper than the upper slope. This style can still be seen in the Society Hill neighborhood of Delancy Street. (Author's collection; photograph by Klaus Krippendorff.)

This daybook of a Swedish immigrant dates from 1804. The unknown owner of the almanac, which was purchased in Gothenburg, provides a calendar and weather reports for the year. The owner would list on blank pages things that needed to be accomplished that day. (Author's collection.)

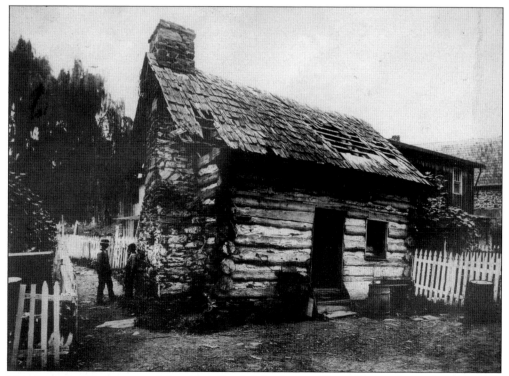

Here is one last look at one of the oldest Swedish log house. This cabin was located in Kellyville and may be the Upper Swedish Log Cabin (no longer standing), but that is not authenticated. The corner chimney, the gambrel roof, and the logs can clearly be seen in this image. (Courtesy of the Print and Picture Department, Free Library of Philadelphia.)

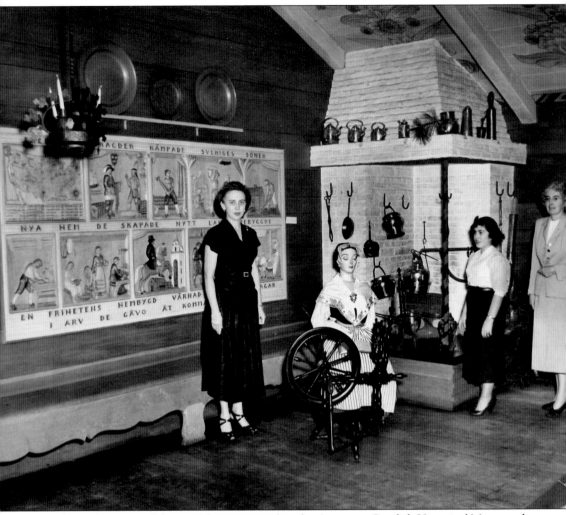

This 1950s image of the stuga (pioneer room) at the American Swedish Historical Museum shows the interior of cabins like the one shown above. This room, designed in 1939, is a romanticized version of a 19th-century Swedish farmhouse. The painted ceiling, corner fireplace, and household objects in this exhibit provide a vision of what life was like inside those cabins. Shown here are visitors from the Independence Square office of Metropolitan life Insurance Company. (Courtesy of the American Swedish Historical Museum.)

This is a digital reproduction of the 1712 portrait of the pastor Erik Björk painted by the famous Swedish American portraitist Gustavus (Gustaf) Hesselius. Erik Björk was one of the three most prominent priests who came from Sweden to the New World by Jesper Svedberg and King Carl IX to revive the churches and serve the remaining Swedes in the Delaware Valley. He was the pastor at Holy Trinity (Old Swedes) Church in Wilmington from 1697 until 1713. (Courtesy of the Nordiska Museet and the Swedish Colonial Society.)

Christina Stalcop, whose portrait was also completed by Hesselius, was the wife of pastor Erik Björk. She was considered a beauty with a Mona Lisa smile, evocative of a sense of mystery and intrigue. (Courtesy of the Nordiska Museet and the Swedish Colonial Society.)

www.arcadiapublishing.com

Discover books about the town where you grew up, the cities where your friends and families live, the town where your parents met, or even that retirement spot you've been dreaming about. Our Web site provides history lovers with exclusive deals, advanced notification about new titles, e-mail alerts of author events, and much more.

MADE IN THE USA

Arcadia Publishing, the leading local history publisher in the United States, is committed to making history accessible and meaningful through publishing books that celebrate and preserve the heritage of America's people and places. Consistent with our mission to preserve history on a local level, this book was printed in South Carolina on American-made paper and manufactured entirely in the United States.

This book carries the accredited Forest Stewardship Council (FSC) label and is printed on 100 percent FSC-certified paper. Products carrying the FSC label are independently certified to assure consumers that they come from forests that are managed to meet the social, economic, and ecological needs of present and future generations.

FSC
Mixed Sources
Product group from well-managed
forests and other controlled sources

Cert no. SW-COC-001530
www.fsc.org
© 1996 Forest Stewardship Council

Find Your Place in History.